Masterpieces of

Constable

(1910)

ISBN-13 : 978-1512353471
ISBN-10 : 1512353477

Copyright©2012-2014 Iacob Adrian

All Rights Reserved.

Notice

This documentary study use historic, archived documents.

Because of this, some pages may look blurry or low quality.

Still are included in this book because they have

high value from critical, documentary, historical,

informative and journalistic point of view .

Dtp and visual art

Iacob Adrian

THE
MASTERPIECES
OF
CONSTABLE
(1776-1837)

Sixty reproductions of photographs from the original paintings affording examples of the different characteristics of the Artist's work

Author statement

This is a series of art books .

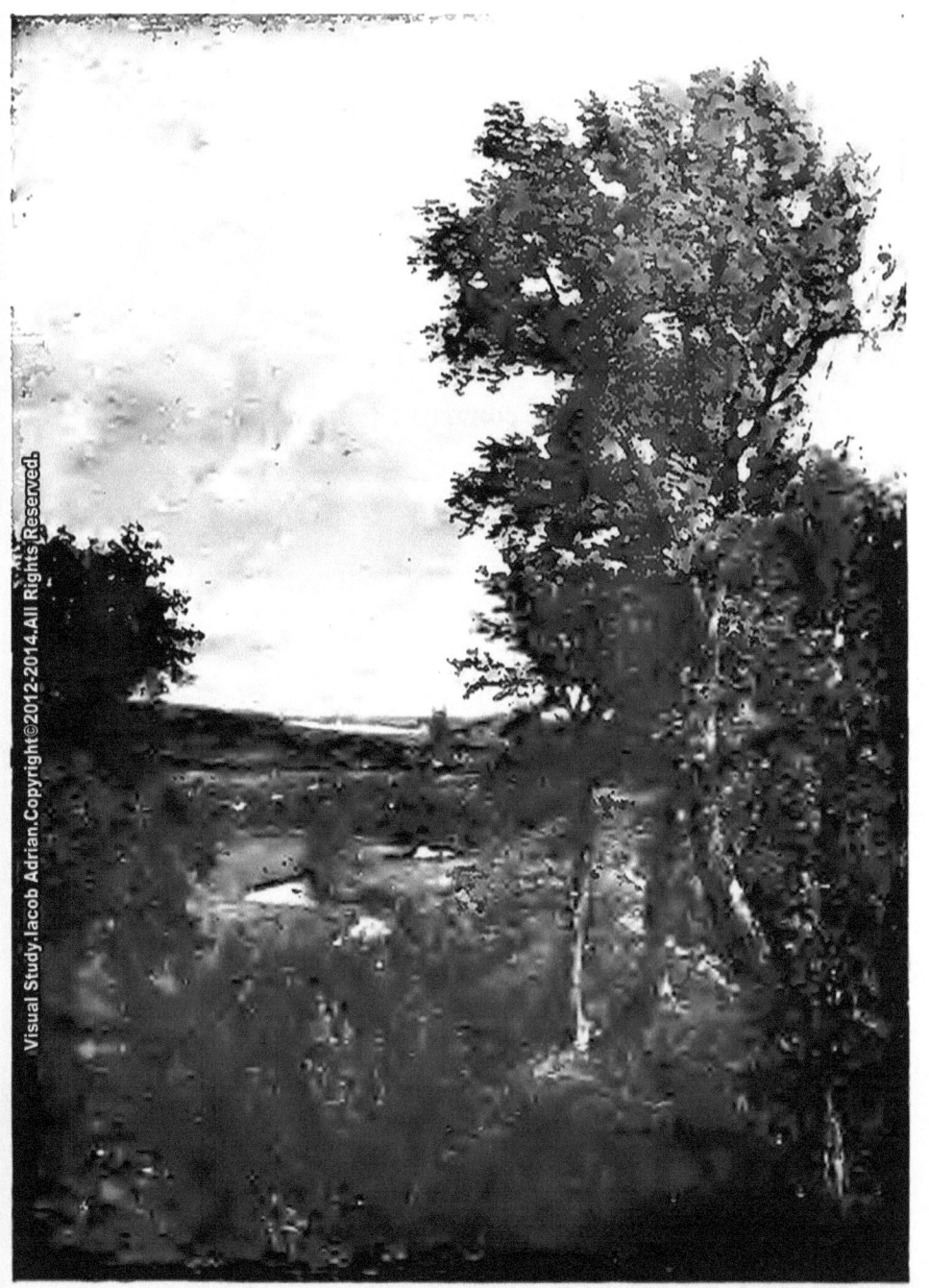

Dedham Vale [1802] La Vallée de Dedham
Das Tal von Dedham
(*Victoria and Albert Museum, South Kensington*)
Gowans & Gray, Ltd., Photo.

This little Book conveys the greetings of

..

to

..

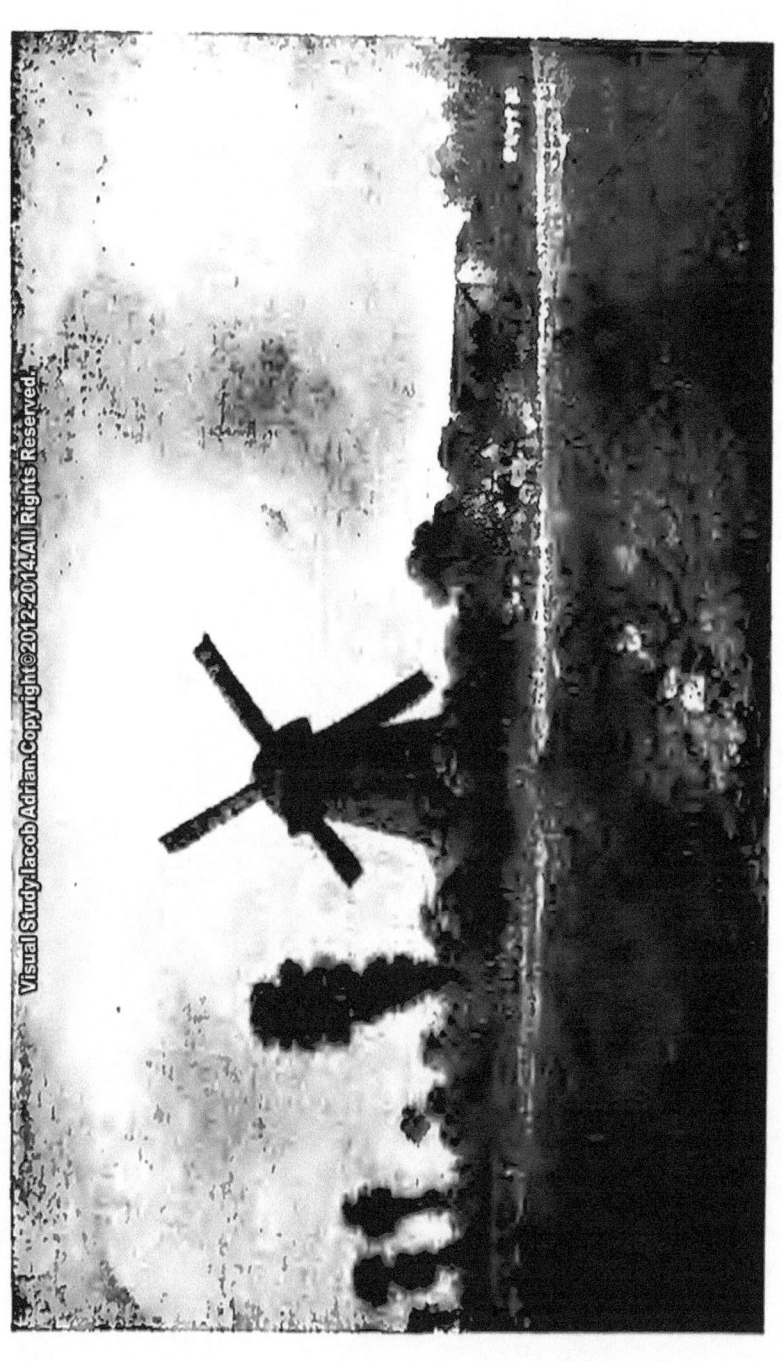

[1805]

ON BARNES COMMON
(National Gallery, London)
SUR LE TERRAIN COMMUNAL A BARNES
(Galerie nationale, Londres)
AUF DER GEMEINDEWEIDE ZU BARNES
(London, Nationalgalerie) Gravans & Gray, Ltd., Photo.

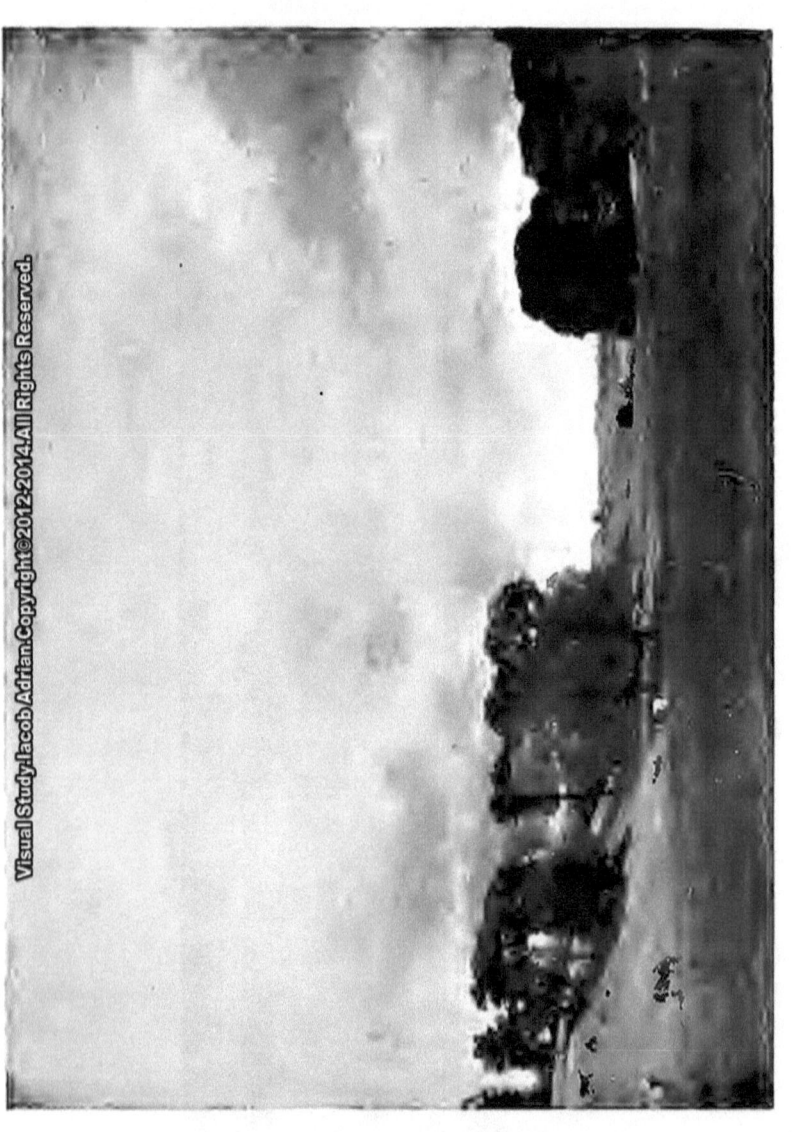

VIEW AT EPSOM [1808] VUE A EPSOM
(National Gallery, London) (Galerie nationale, Londres)
ANSICHT ZU EPSOM
(London, Nationalgalerie) Gowans & Gray, Ltd., Photo.

DEDHAM VALE [1809] LA VALLÉE DE DEDHAM
(National Gallery, London) (Galerie nationale, Londres)
DAS TAL VON DEDHAM Gowans & Gray, Ltd., Photo.
(London, Nationalgalerie)

Constable's Birthplace, Bergholt, Sussex Lieu de Naissance de Constable, Bergholt, Sussex
Geburtsort Constables, Bergholt, Sussex
[1809]
(Tate Gallery, London) Gowans & Gray, Ltd., Photo.

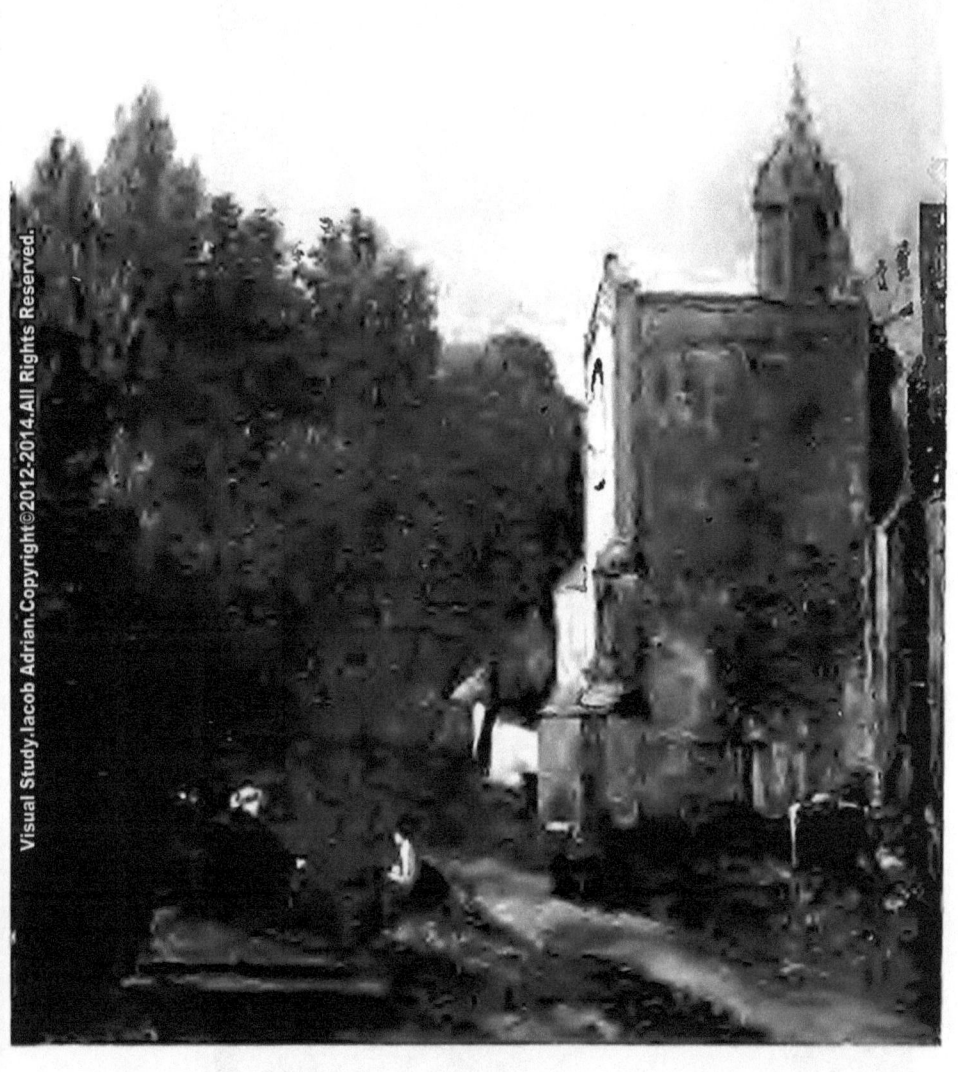

[1811]
CHURCH PORCH, BERGHOLT, SUSSEX
PORTIQUE D'ÉGLISE, BERGHOLT, SUSSEX
KIRCHENVORHALLE IN BERGHOLT, SUSSEX
(Tate Gallery, London)
Gowans & Gray, Ltd., Photo.

VILLAGE FAIR

[1811]

DORFMESSE

FOIRE DE VILLAGE

(*Victoria and Albert Museum, South Kensington*)

Gowans & Gray, Ltd., Photo.

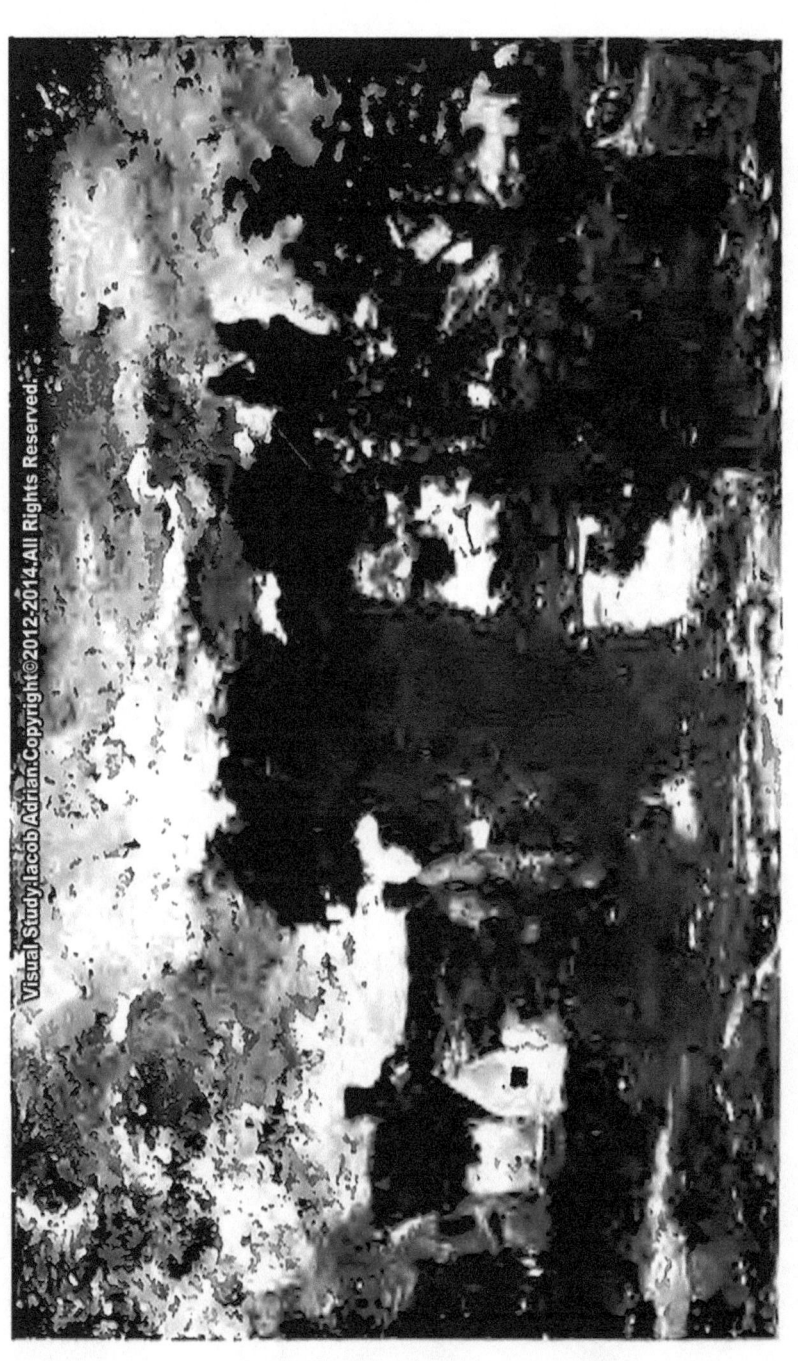

THE MILL STREAM, FLATFORD [1811] LE RUISSEAU DU MOULIN, FLATFORD
(*National Gallery, London*) (*Galerie nationale, Londres*)
DER MÜHLBACH, FLATFORD
(*London, Nationalgalerie*) *Gowans & Gray, Ltd., Photo.*

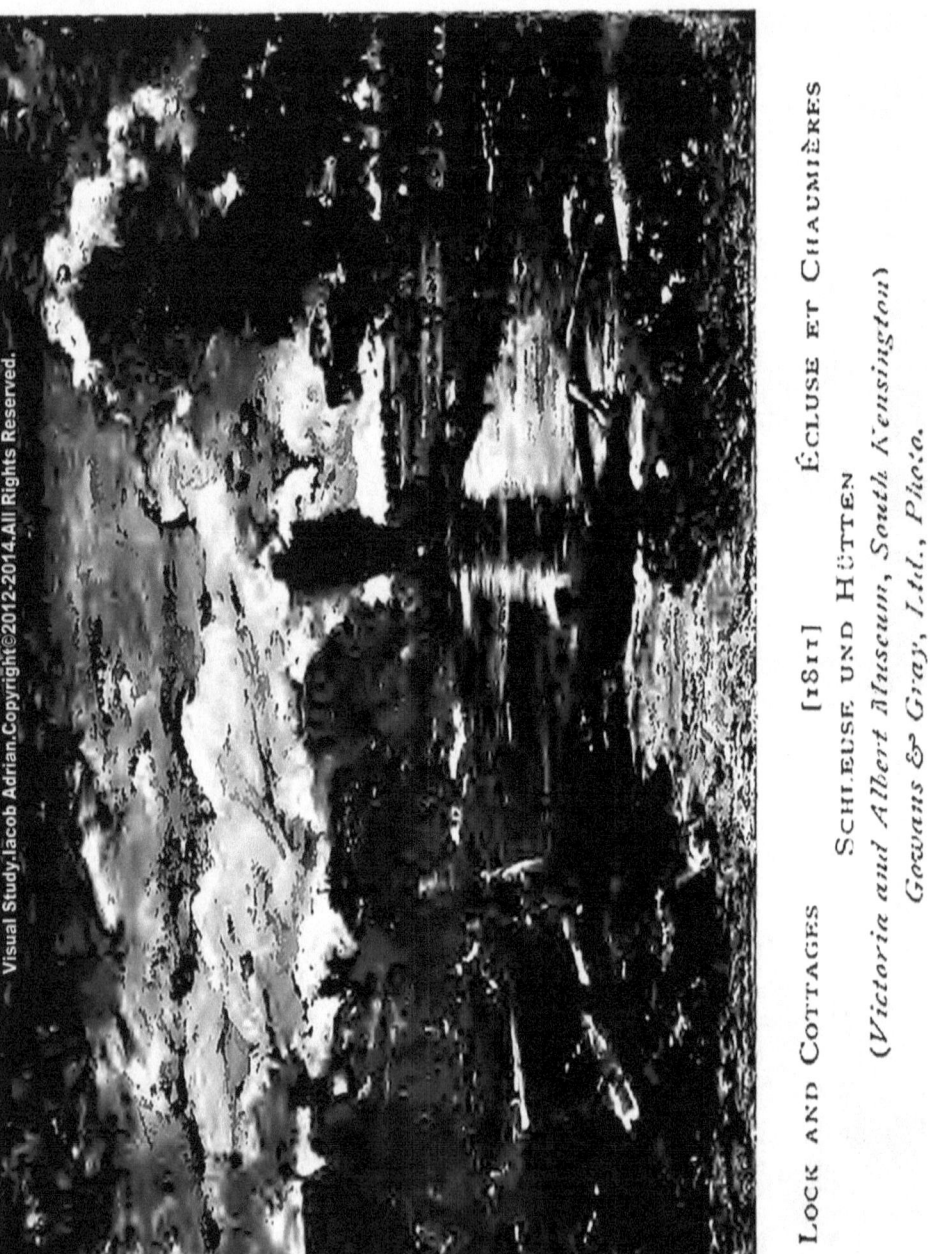

LOCK AND COTTAGES [1811] ÉCLUSE ET CHAUMIÈRES
SCHLEUSE UND HÜTTEN
(*Victoria and Albert Museum, South Kensington*)
Gowans & Gray, Ltd., Photo.

[1872] LANDSCAPE WITH DOUBLE RAINBOW PAYSAGE AVEC DOUBLE ARC-EN-CIEL
LANDSCHAFT MIT DOPPELTEM REGENBOGEN
(Victoria and Albert Museum, South Kensington) Gowans & Gray, Ltd., Photo.

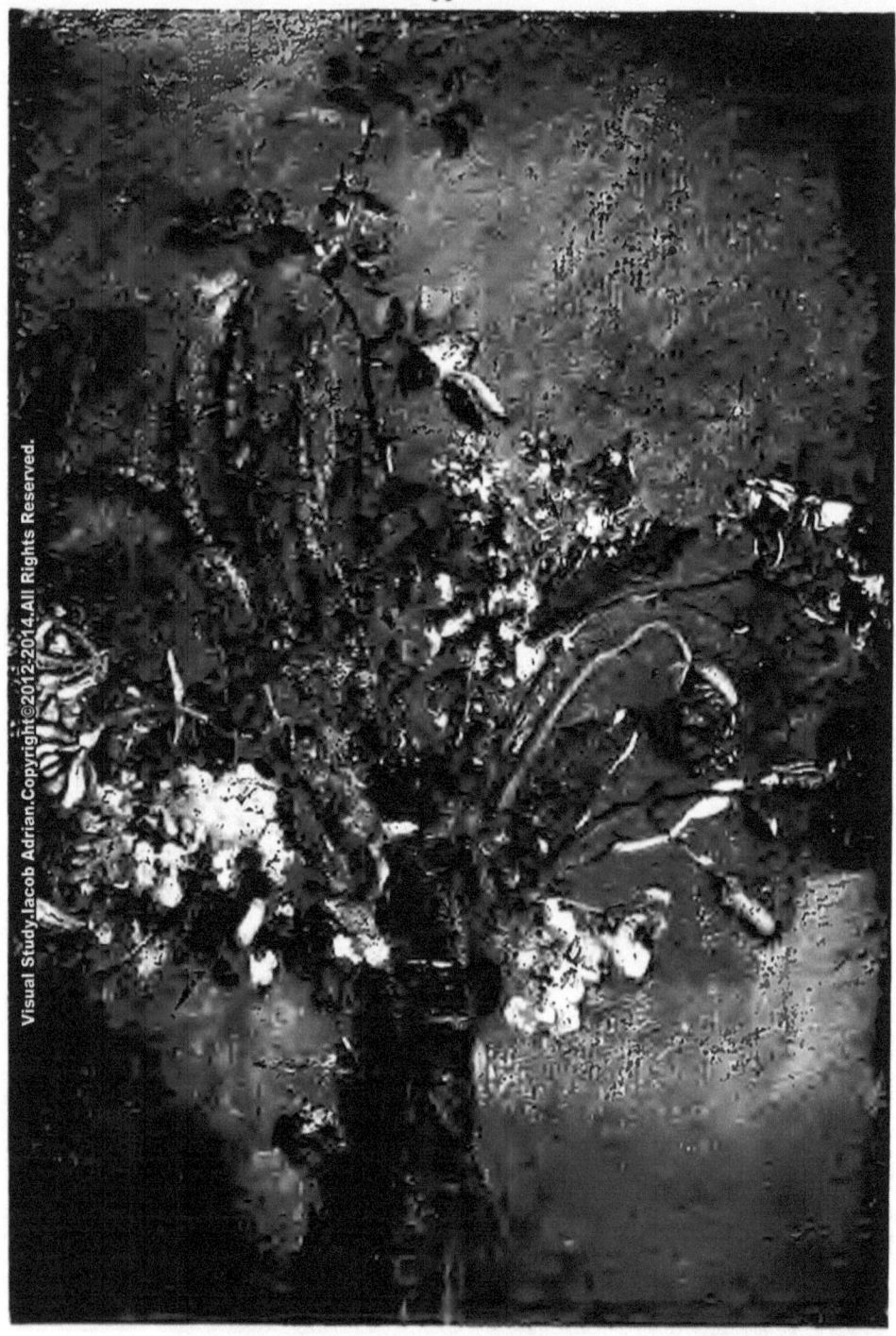

[1814]
STUDY OF FLOWERS BLUMENSTUDIE ÉTUDE DE FLEURS
(*Victoria and Albert Museum, South Kensington*)
Gowans & Gray, Ltd., Photo.

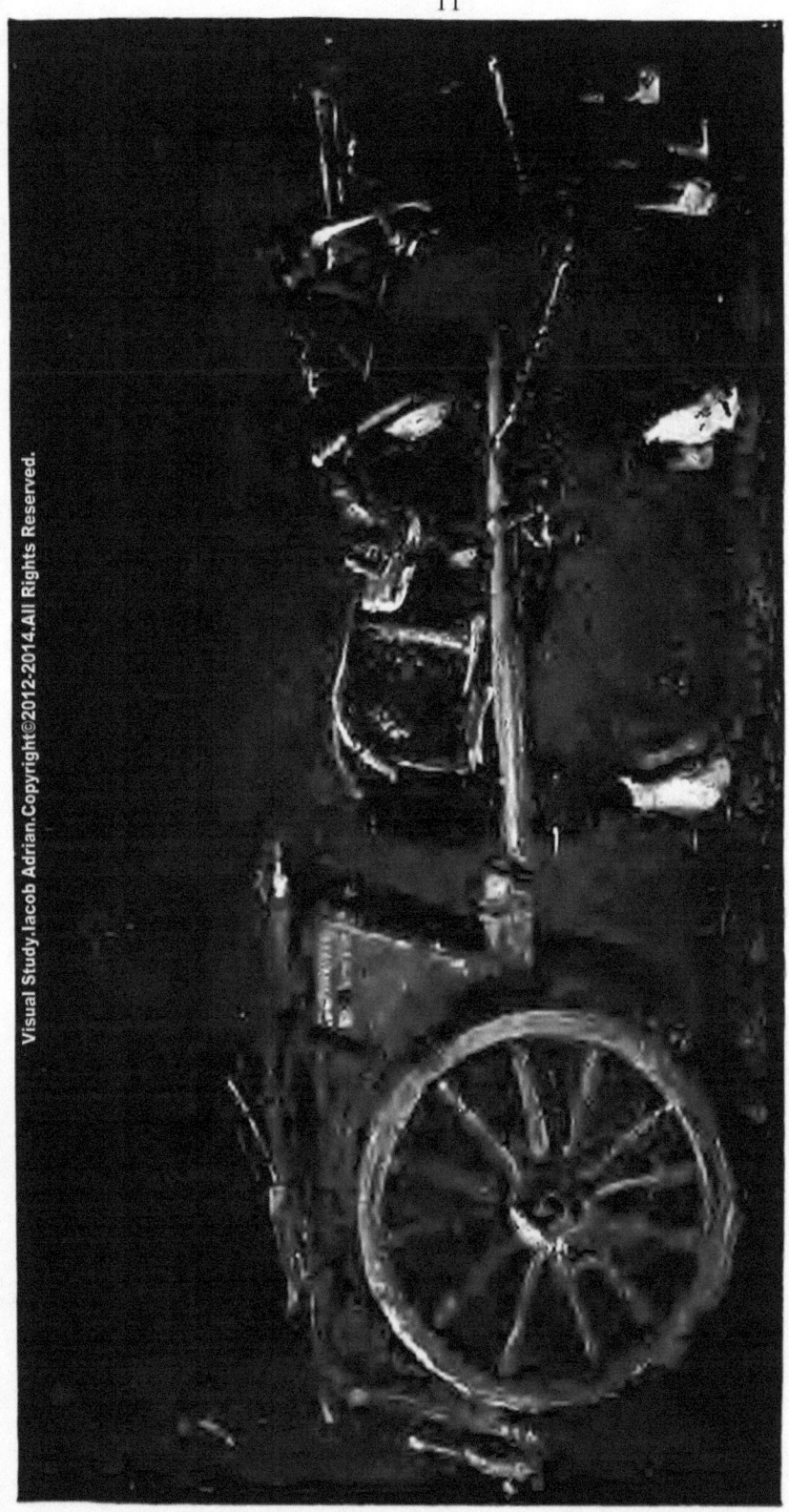

CART AND HORSES
KARREN UND PFERDE
CHARRETTE ET CHEVAUX
[1814]
(Victoria and Albert Museum, South Kensington)

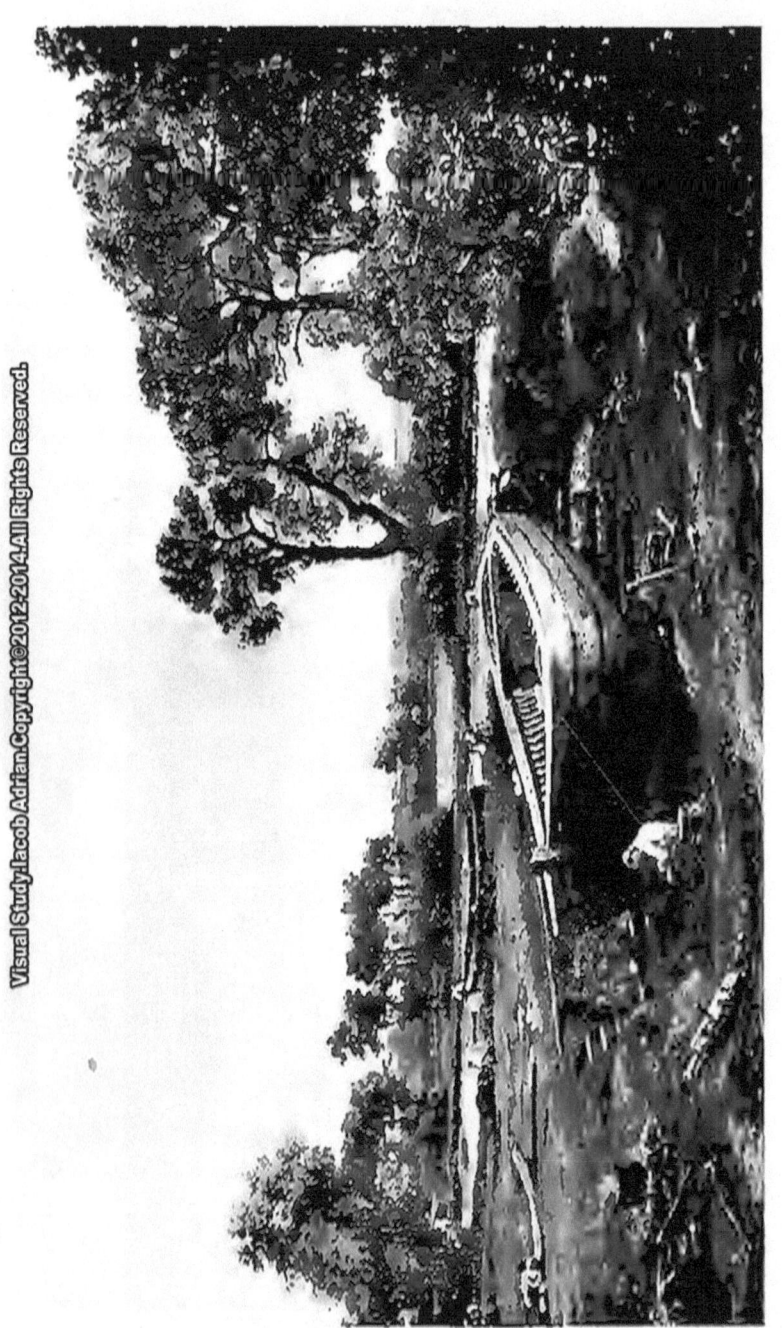

[1815] BOATBUILDING, NEAR FLATFORD MILL CONSTRUCTION DE BATEAUX, PRÈS LE MOULIN DE FLATFORD
BOOTBAU, NAHE BEI DER MÜHLE VON FLATFORD
(Victoria and Albert Museum, South Kensington) *Gowans & Gray, Ltd., Photo.*

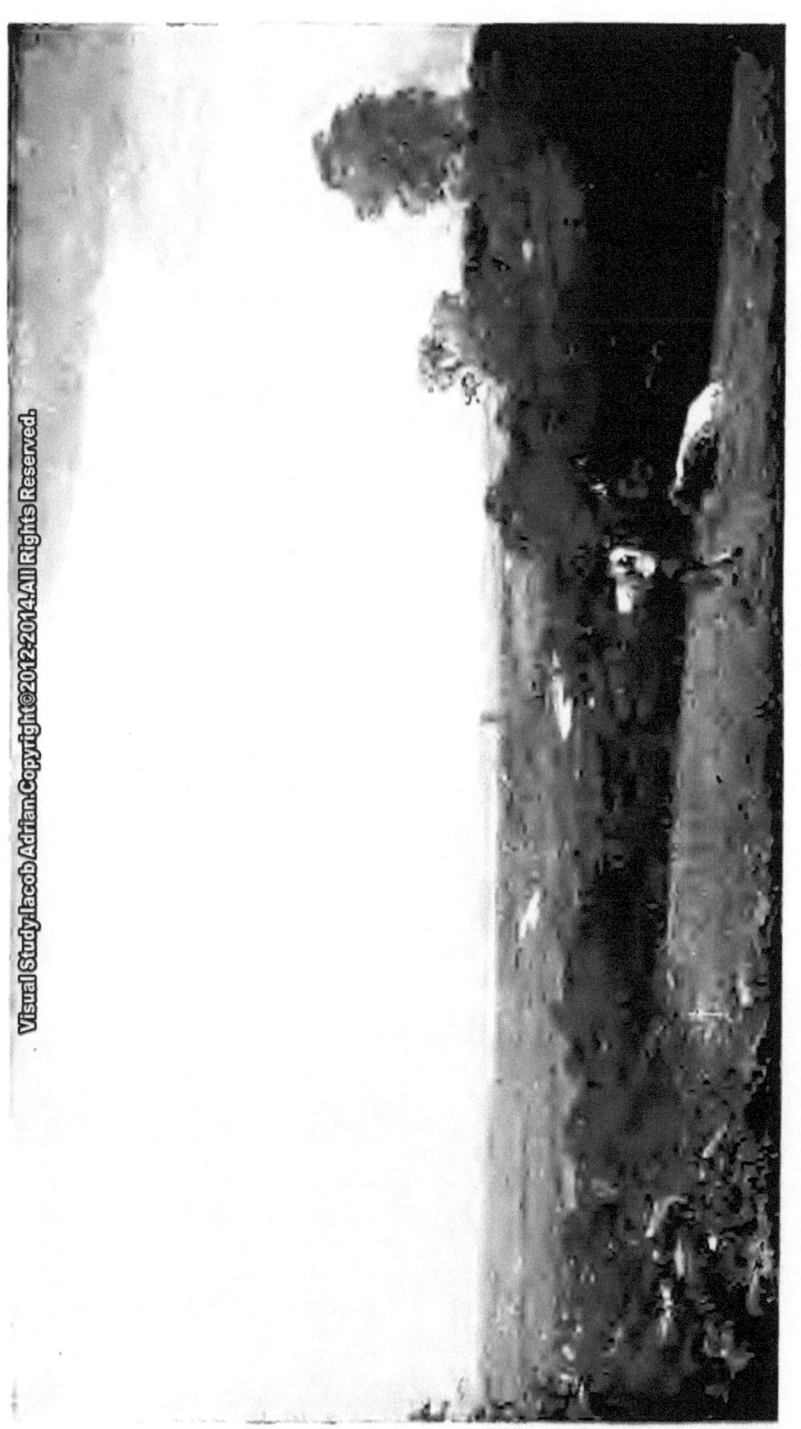

Dedham Vale
[1815]
Das Tal von Dedham La Vallée de Dedham
(Victoria and Albert Museum, South Kensington)
Graves & Gray, Ltd., Photo.

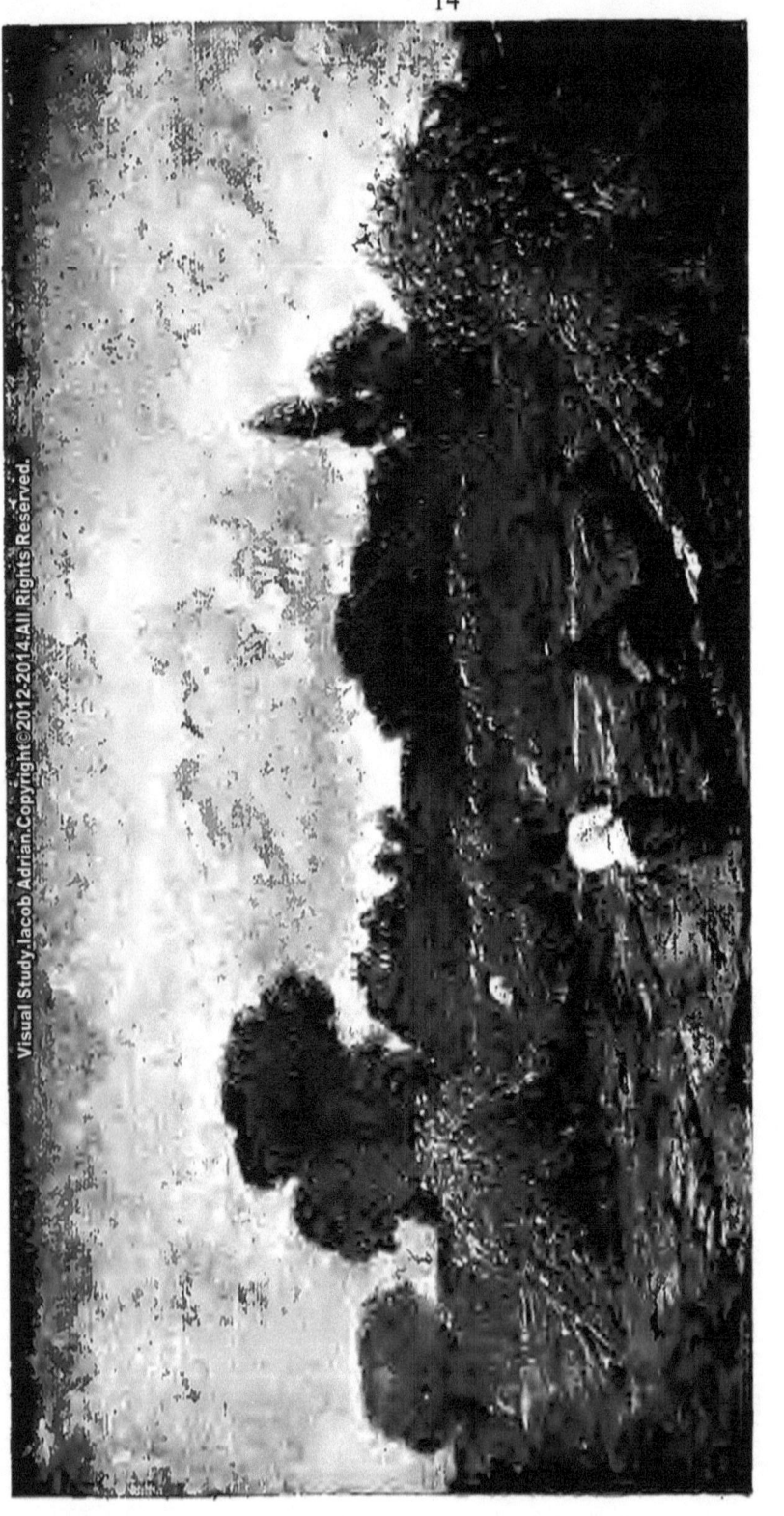

[1816]

CORNFIELD, WITH FIGURES KORNFELD, MIT FIGUREN CHAMP DE BLÉ, AVEC DES FIGURES
(National Gallery, London) (London, Nationalgalerie) (Galerie nationale, Londres)

Gowans & Gray, Ltd., Photo.

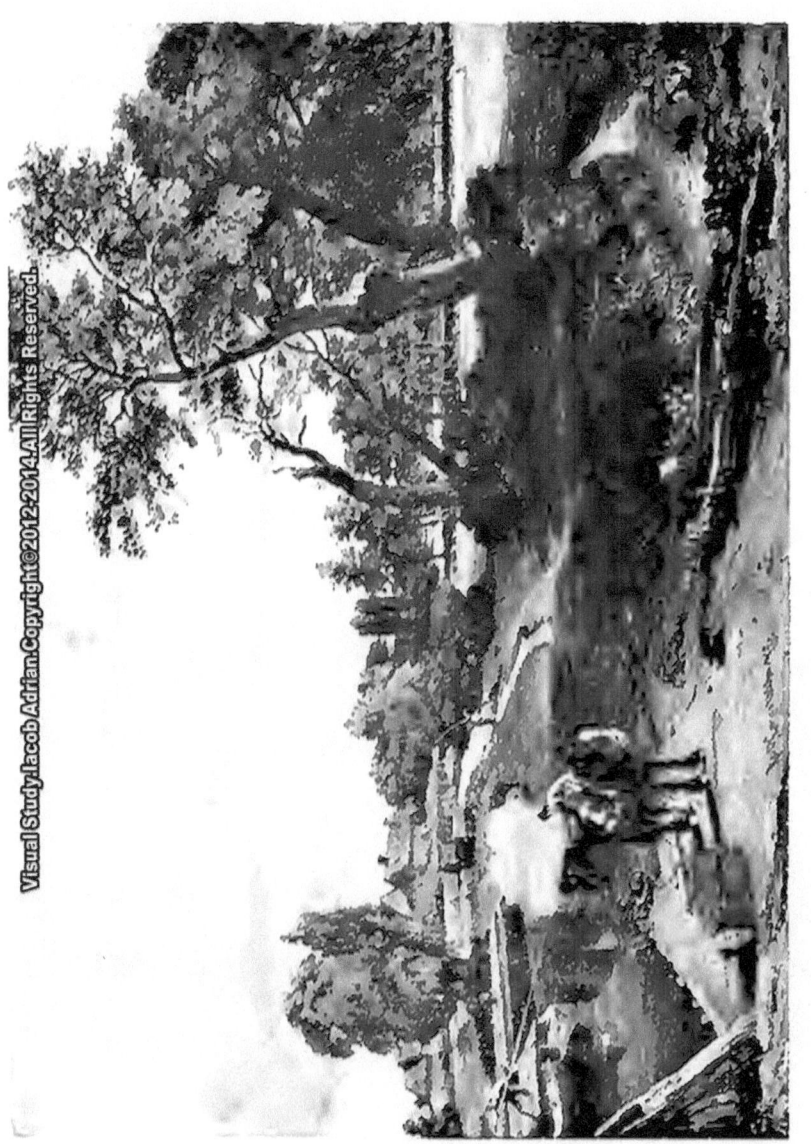

FLATFORD MILL ON THE RIVER STOUR [1817] LE MOULIN DE FLATFORD, SUR LA STOUR, RIVIÈRE
(National Gallery, London) (Galerie nationale, Londres)
DIE MÜHLE VON FLATFORD, AUF DEM FLUSS STOUR
(London, Nationalgalerie) F. Hanfstaengl, Photo.

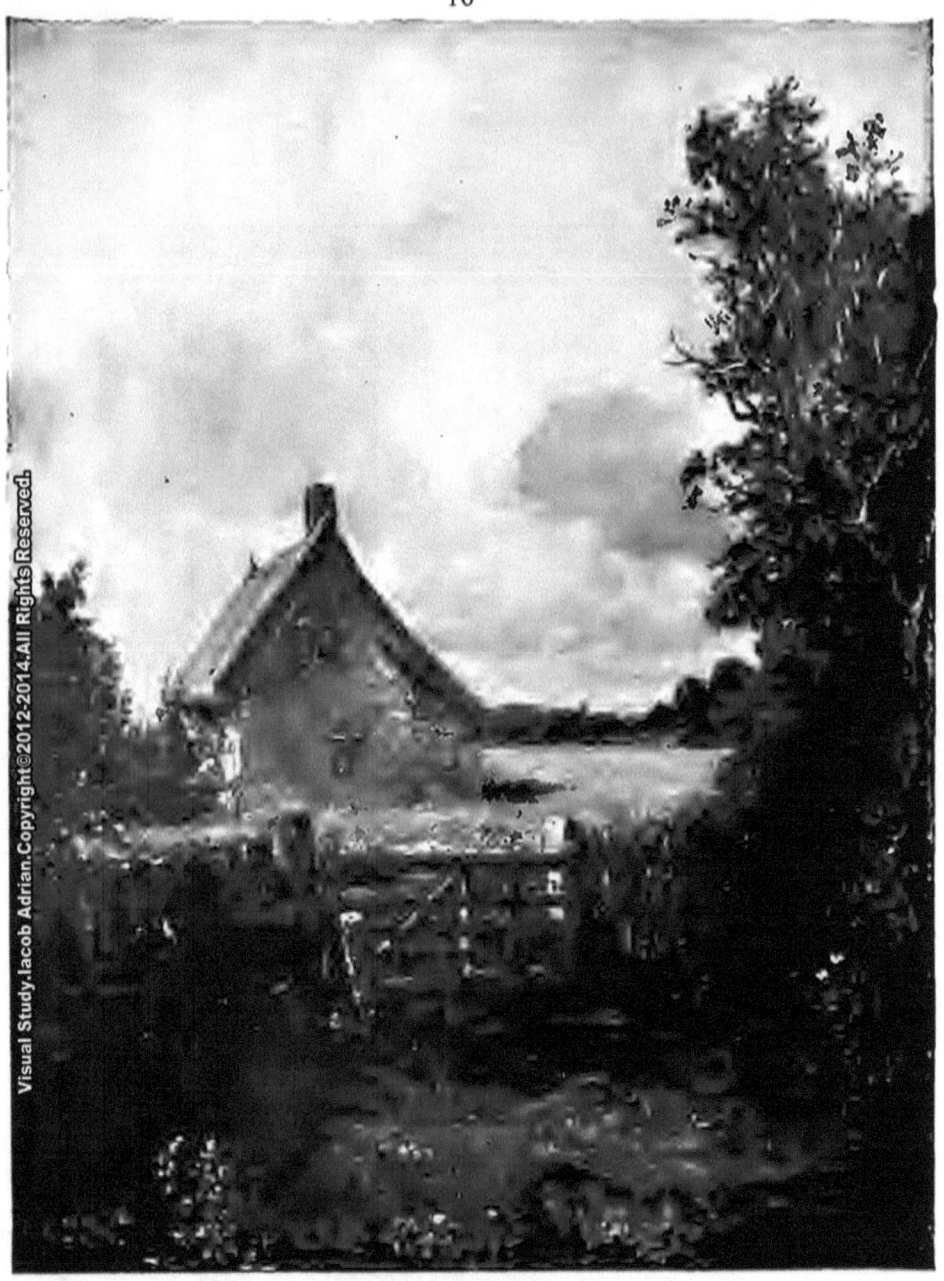

[1818]

THE COTTAGE IN THE CORNFIELD LA CHAUMIÈRE DANS LE CHAMP DE BLÉ

DIE HÜTTE IM KORNFELD

(*Victoria and Albert Museum, South Kensington*)

Gowans & Gray, Ltd., Photo.

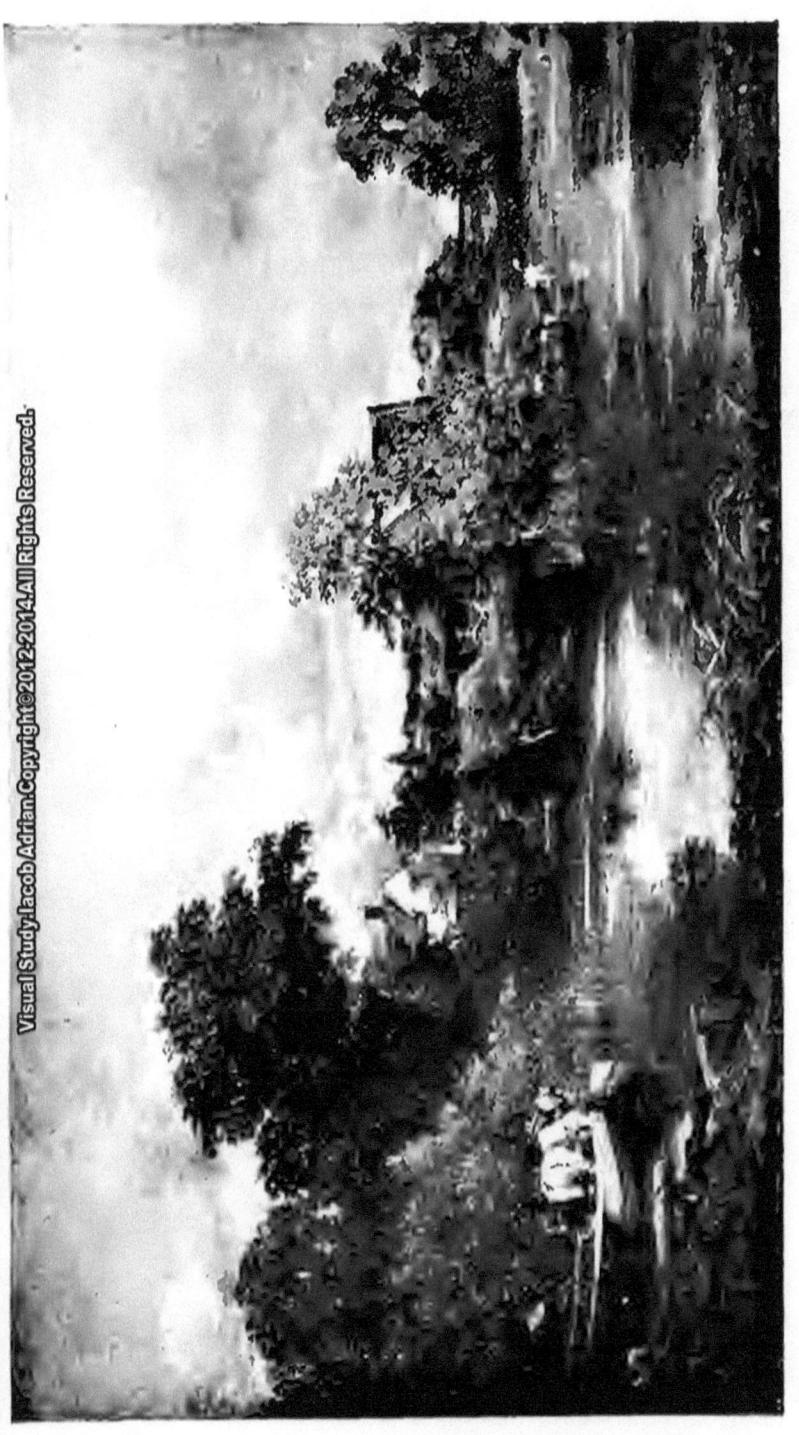

SCENE ON THE RIVER STOUR [1819] SCÈNE SUR LA STOUR, RIVIÈRE
("THE WHITE HORSE") ("LE CHEVAL BLANC")
SZENE AUF DEM FLUSSE STOUR ("DAS WEISSE PFERD")
(Mr. J. Pierpont Morgan, London)

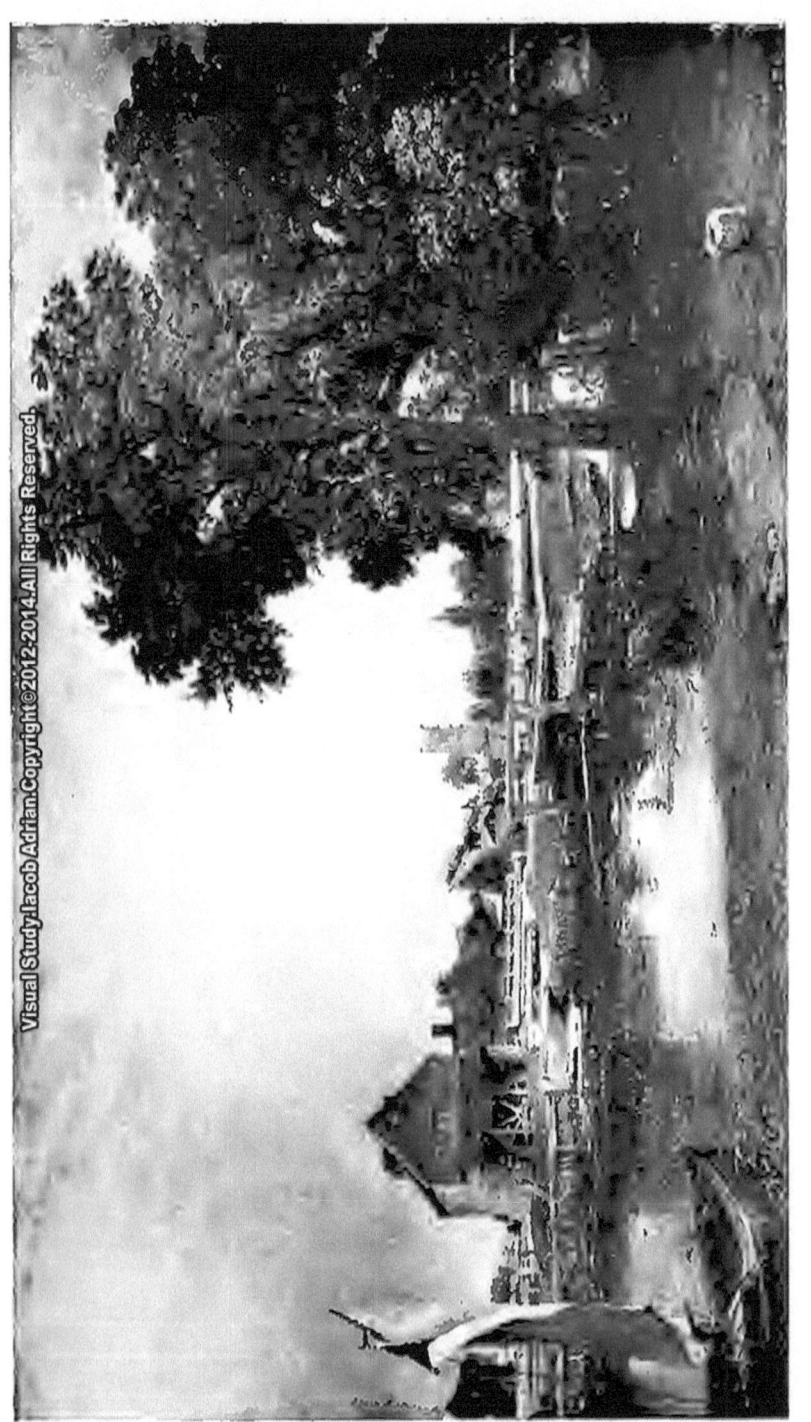

Dedham Mill. Die Mühle von Dedham. Le Moulin de Dedham
[1820]
(*Victoria and Albert Museum, South Kensington*)
Gowans & Gray, Ltd., Photo.

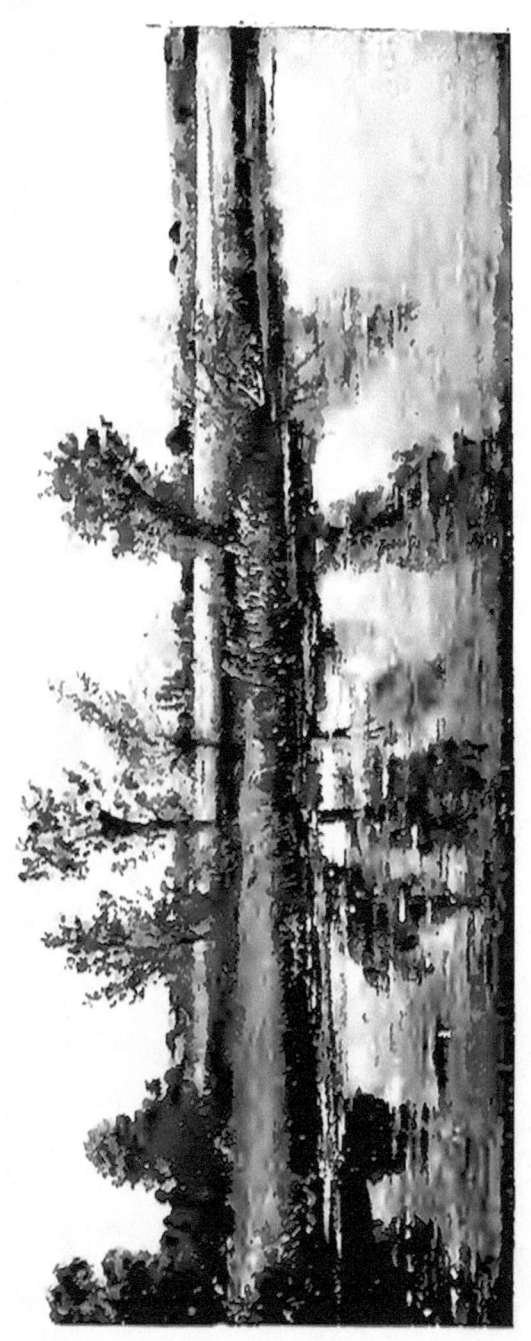

WATER MEADOWS, NEAR SALISBURY [1820] PRÉS D'EAU, PRÈS SALISBURY
WASSERWIESEN, NAHE BEI SALISBURY
(*Victoria and Albert Museum, South Kensington*)
Gowans & Gray, Ltd., Photo.

HARWICH: SEA AND LIGHTHOUSE [1820] HARWICH: MER ET PHARE
HARWICH: MEER UND LEUCHTTURM
(*Tate Gallery, London*)
Gowans & Gray, Ltd., Photo.

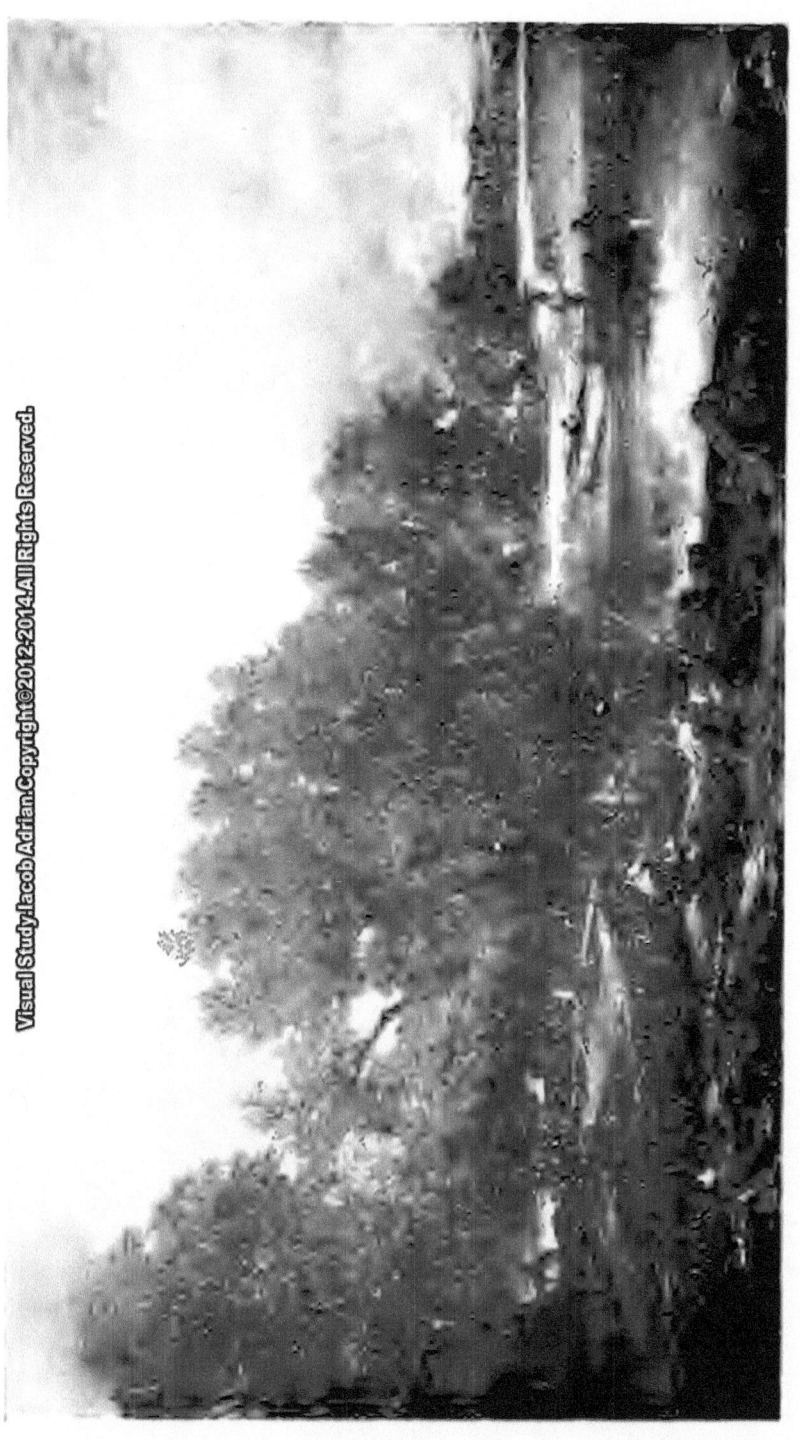

STRATFORD MILL ON THE RIVER STOUR [1820] LE MOULIN DE STRATFORD, SUR LA STOUR, RIVIÈRE
DIE MÜHLE VON STRATFORD, AUF DEM FLUSS STOUR
(Lord Swaythling, London) A. Rischgitz, Photo.

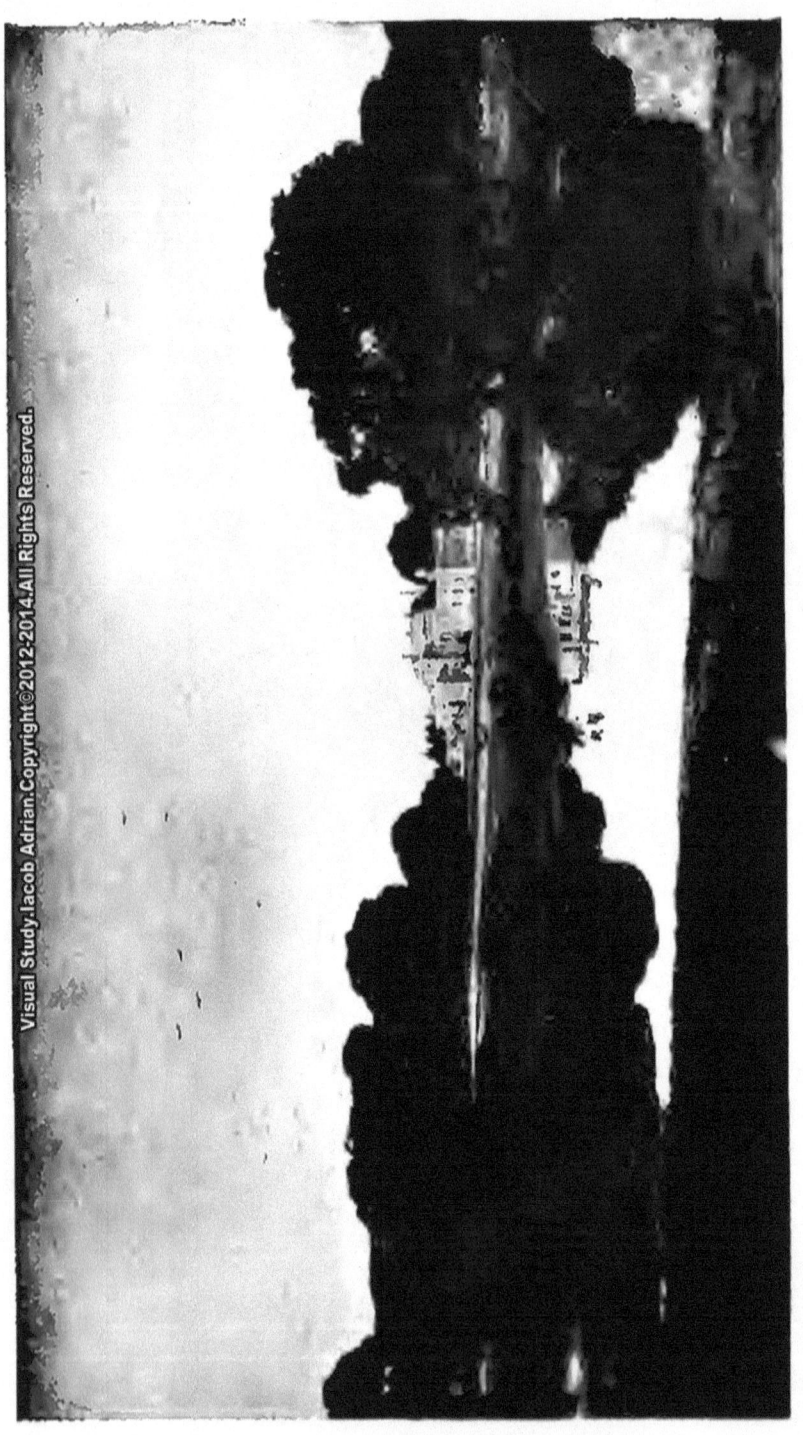

[1820]
MALVERN HALL, SPETCHLEY
(*National Gallery, London*)
Gowans & Gray, Ltd., Photo.

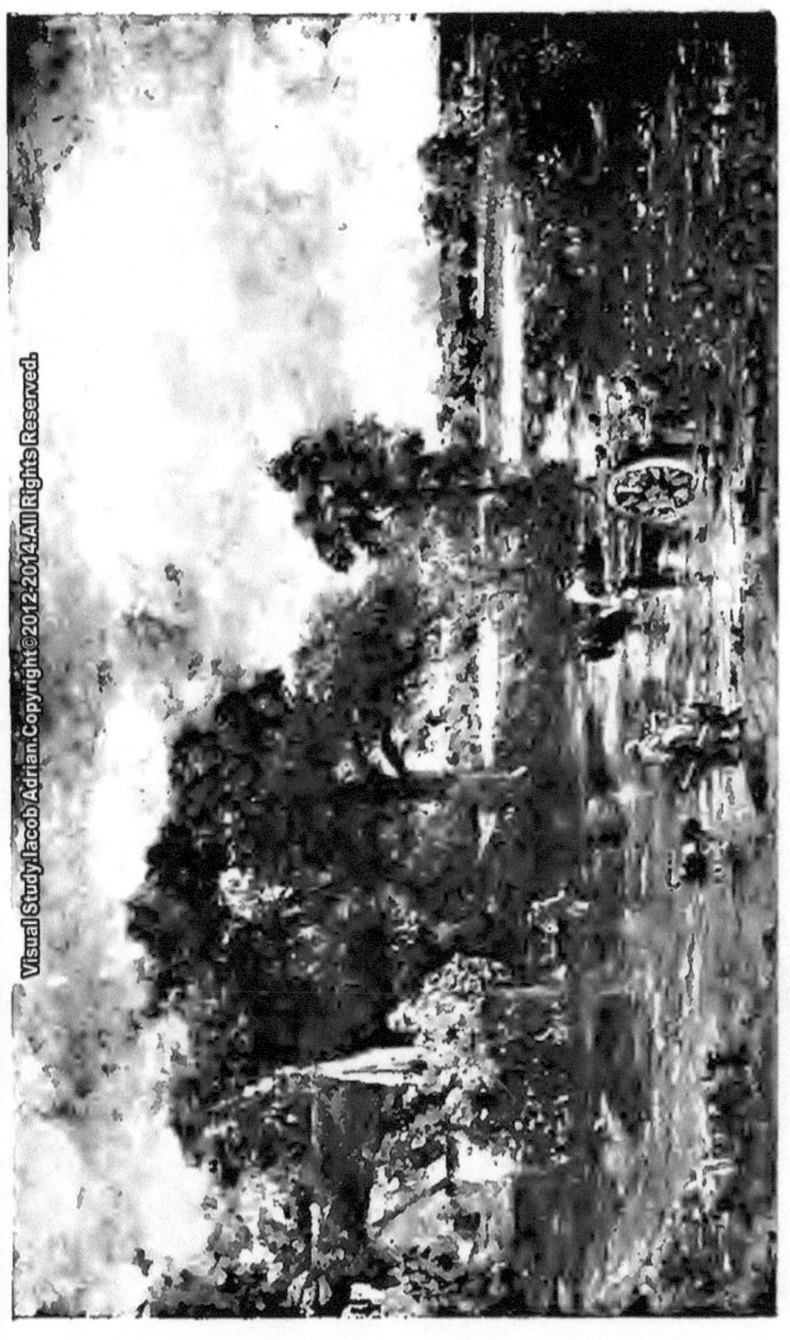

STUDY FOR "THE HAY WAIN" [1821] ÉTUDE POUR "LA CHARRETTE A FOIN"
STUDIE FÜR "DEN HEUWAGEN"
(Victoria and Albert Museum, South Kensington)
Gowans & Gray, Ltd., Photo.

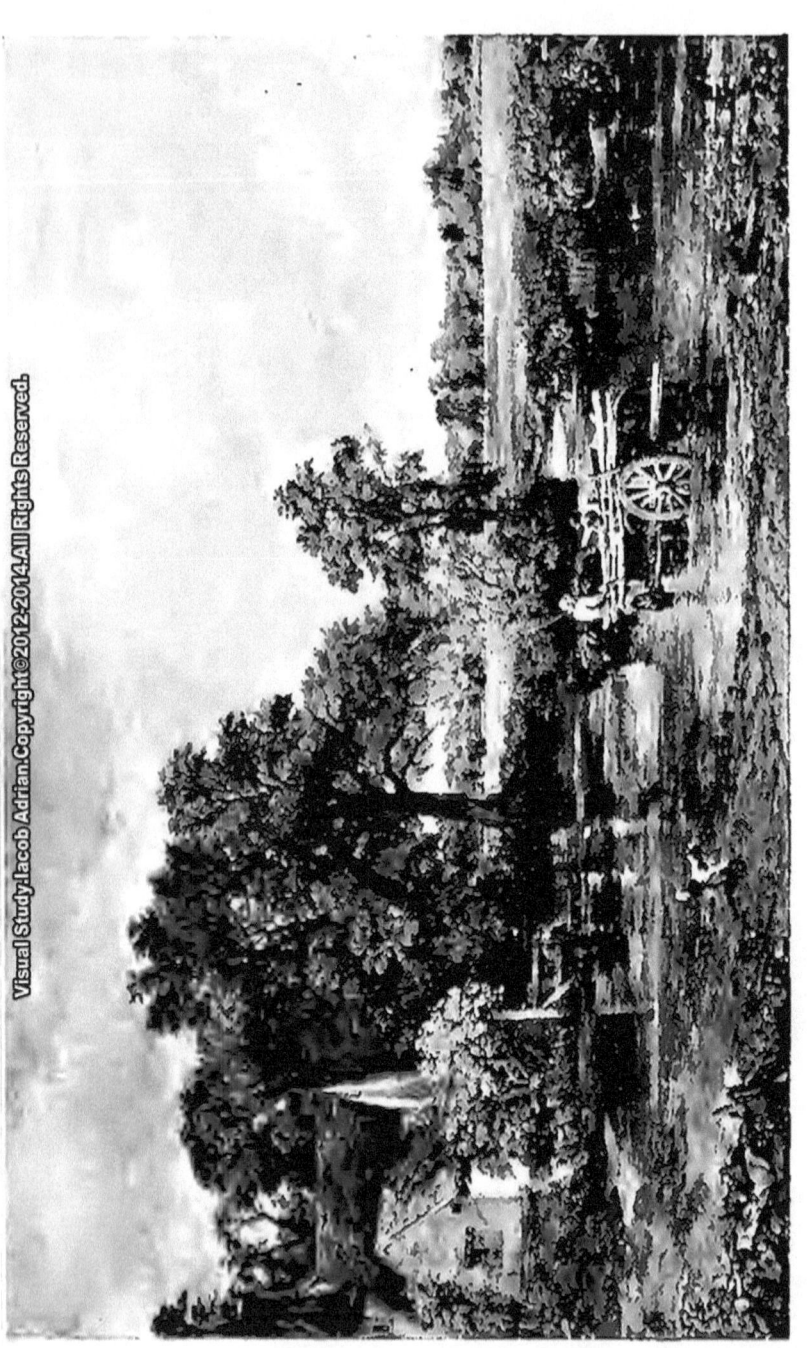

THE HAY WAIN
(National Gallery, London)

[1821]
DER HEUWAGEN
(London, Nationalgalerie)
F. Hanfstaengl, Photo.

LA CHARRETTE A FOIN
(Galerie nationale, Londres)

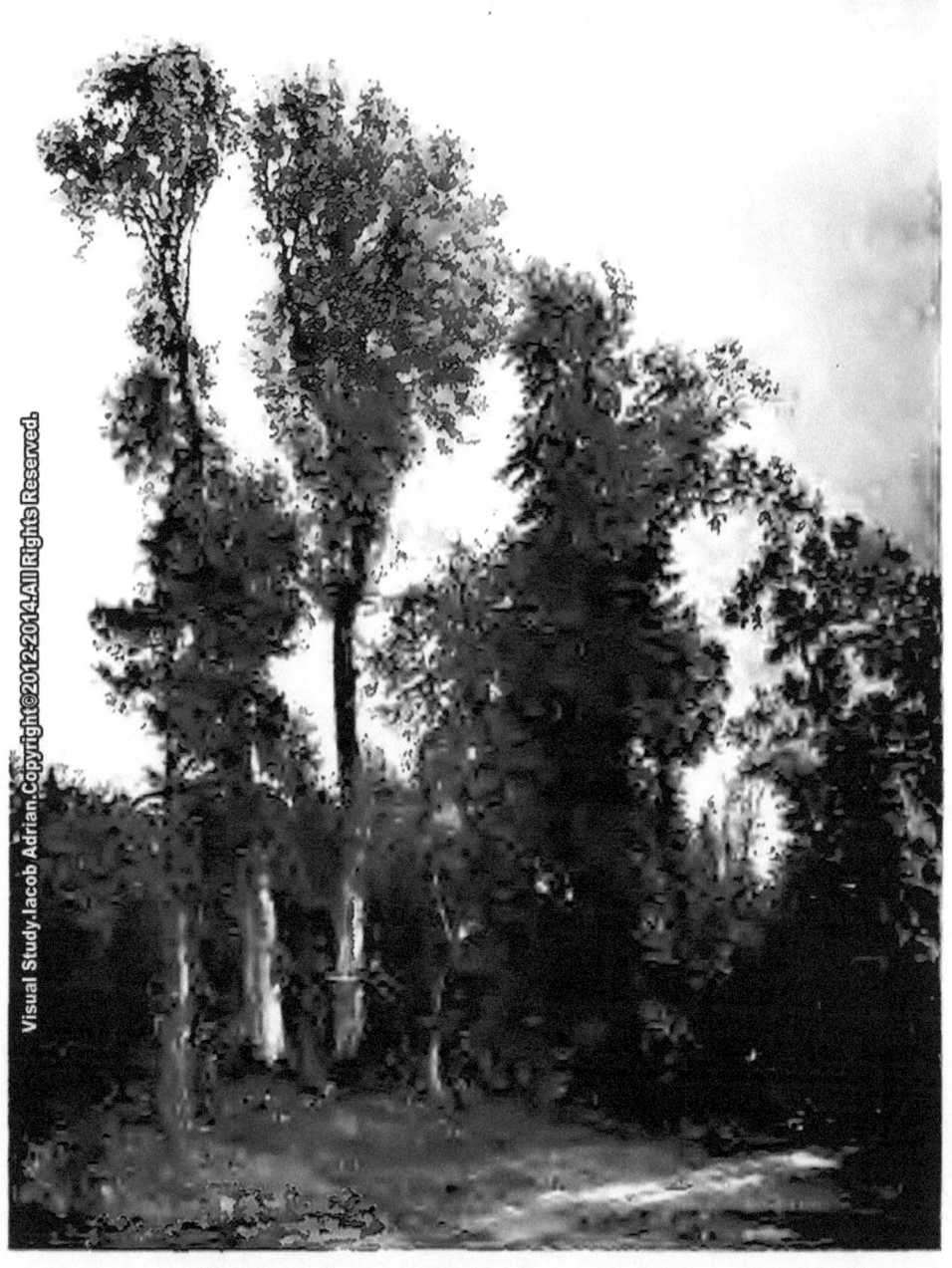

TREES NEAR HAMPSTEAD [1821] ARBRES PRÈS L'ÉGLISE DE
CHURCH HAMPSTEAD
BÄUME NAHE BEI DER KIRCHE ZU HAMPSTEAD
(*Victoria and Albert Museum, South Kensington*)
Gowans & Gray, Ltd., Photo.

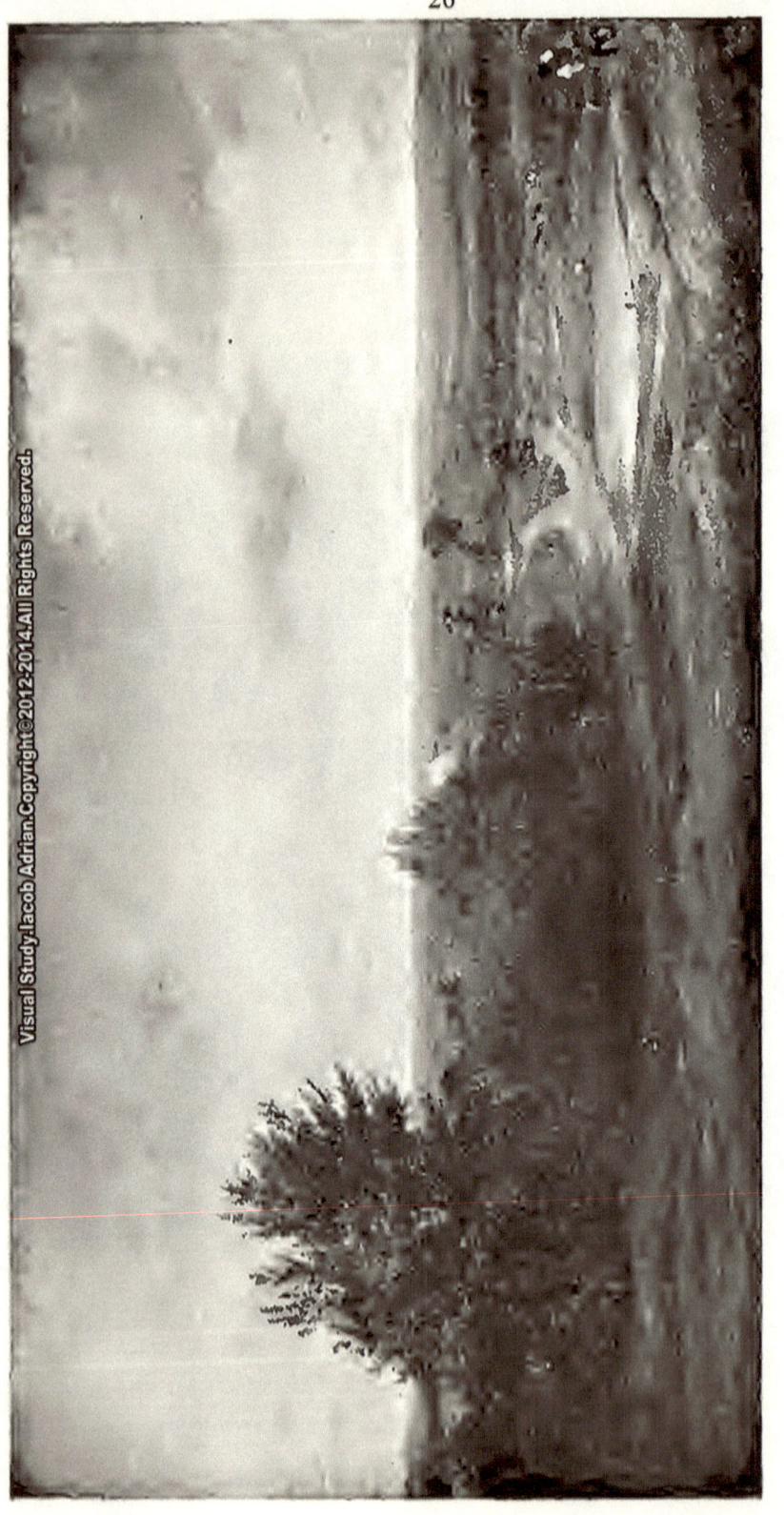

"THE SALT-BOX," HAMPSTEAD HEATH [1821] "LA SALIÈRE," LANDE DE HAMPSTEAD
"DAS SALZFASS," HAMPSTEAD HEIDE
(*Tate Gallery. London*) *Gowans & Gray, Ltd., Photo.*

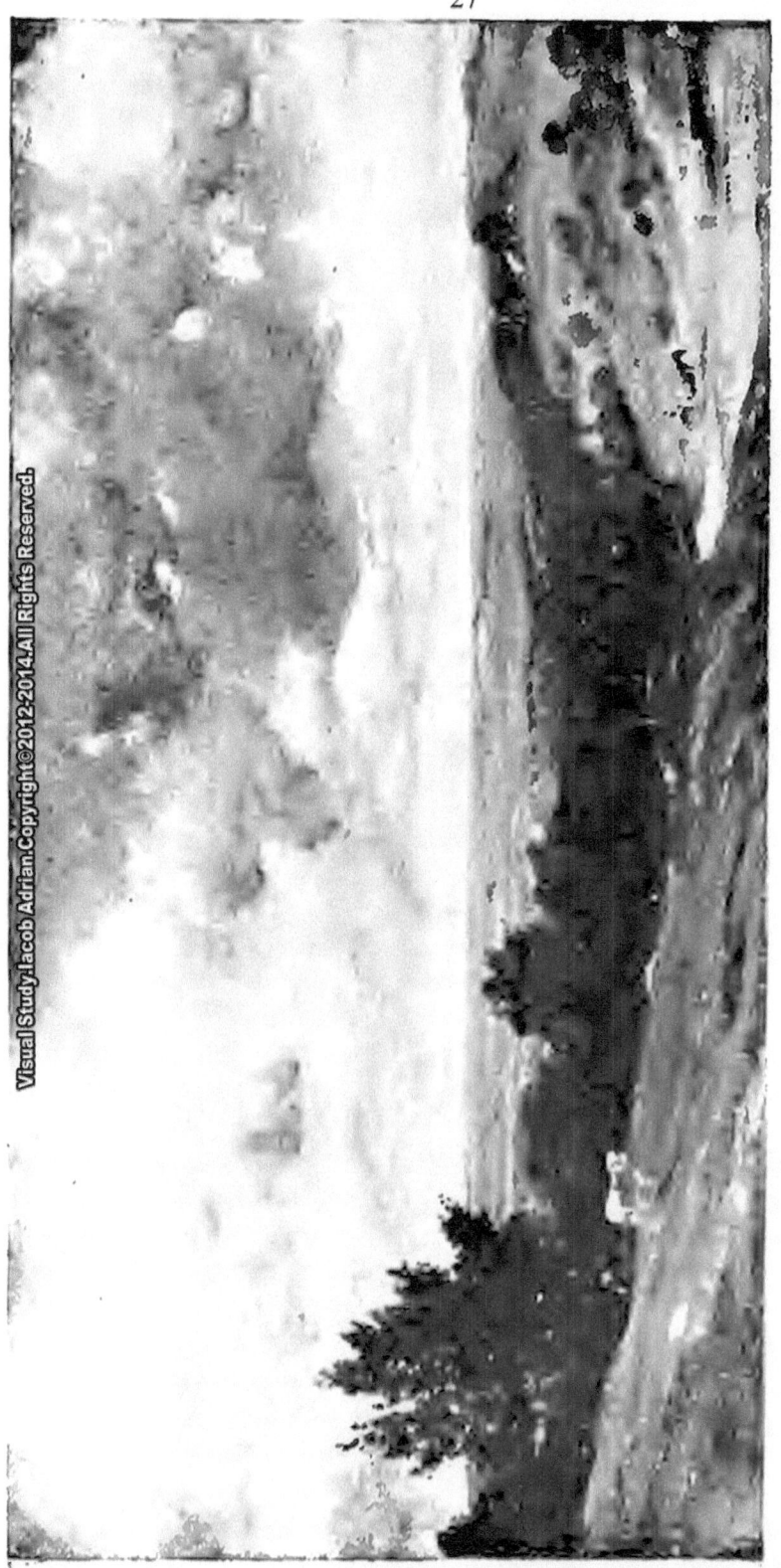

HAMPSTEAD HEATH [1821] HAMPSTEAD HEIDE LANDE DE HAMPSTEAD
(Tate Gallery, London)
Gowans & Gray, Ltd., Photo.

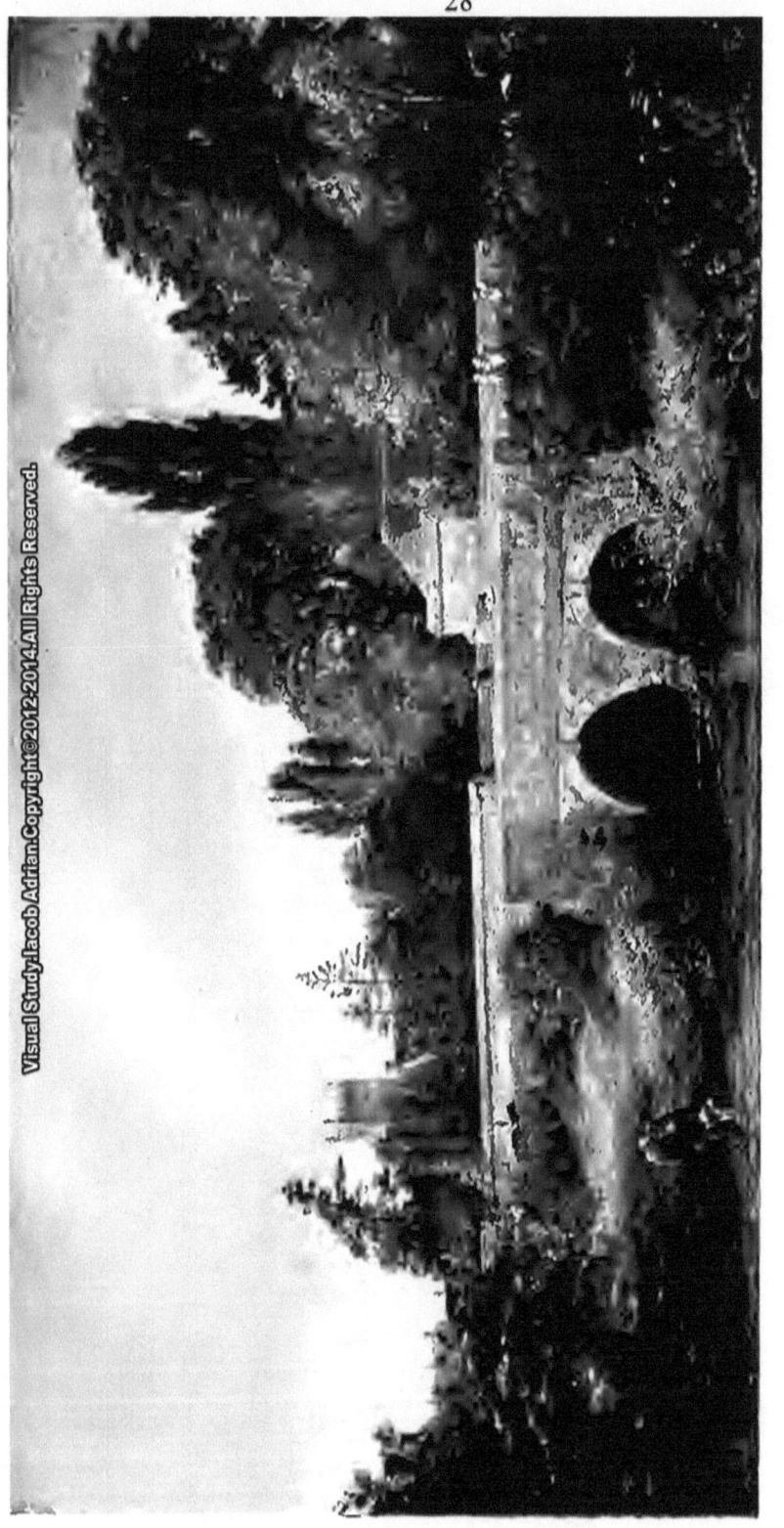

THE BRIDGE AT GILLINGHAM DIE BRÜCKE ZU GILLINGHAM LE PONT A GILLINGHAM
[1821]
(Tate Gallery, London)
Gowans & Gray, Ltd., Photo.

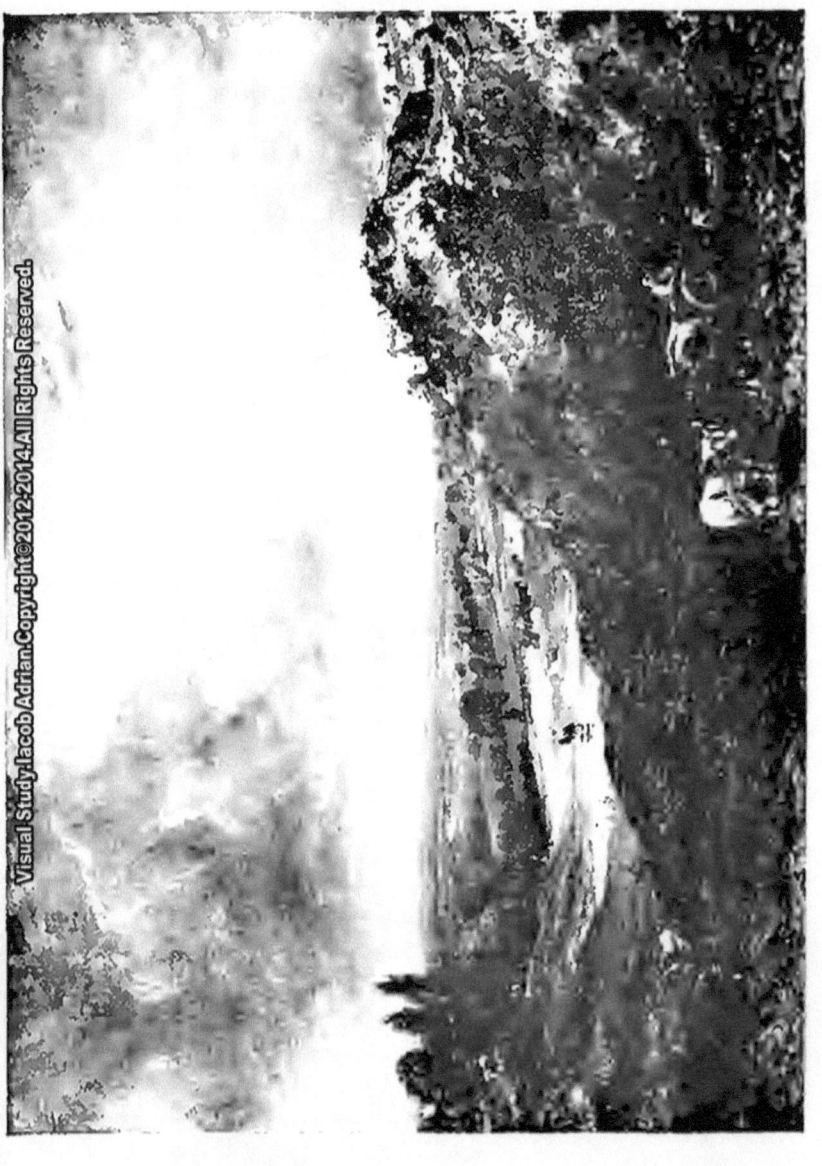

HAMPSTEAD HEATH HAMPSTEAD HEIDE LANDE DE HAMPSTEAD
[1822]
(*Victoria and Albert Museum, South Kensington*)

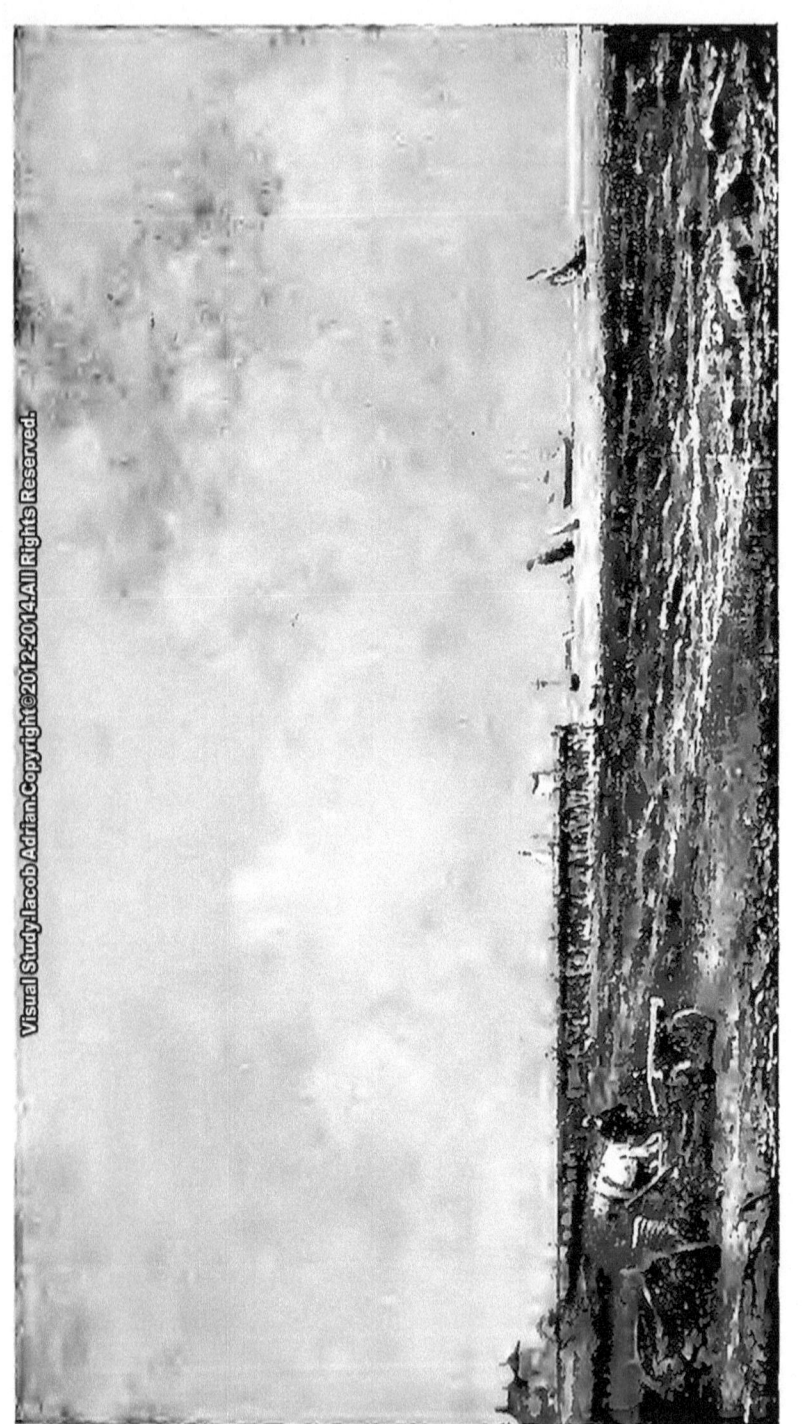

YARMOUTH JETTY HAFENDAMM VON YARMOUTH LA JETÉE DE YARMOUTH
[1822]
(*Lord Glenconner, London*)
W. A. Mansell & Co., Photo.

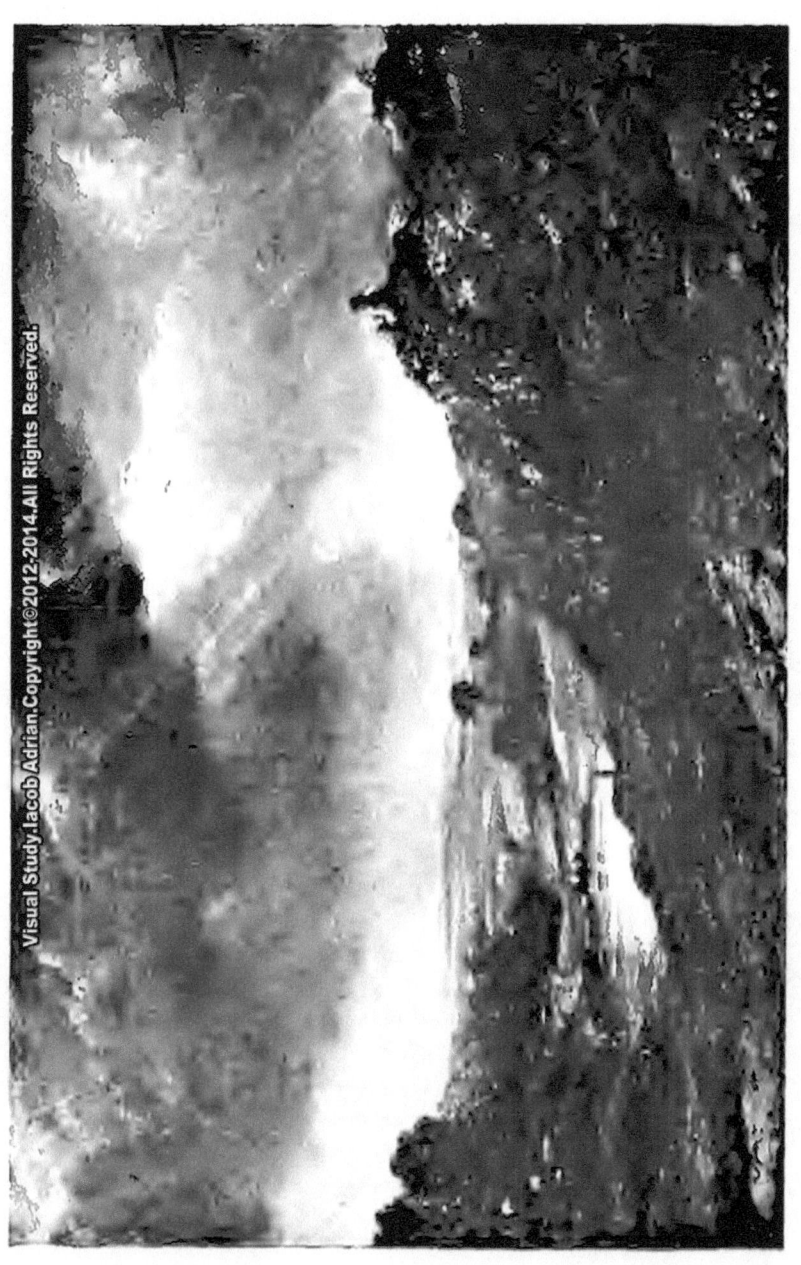

HAMPSTEAD HEATH
(*National Gallery, London*)

[1823]
HAMPSTEAD HEIDE
(*London, Nationalgalerie*)
Gowans & Gray, Ltd., Photo.

LANDE DE HAMPSTEAD
(*Galerie nationale, Londres*)

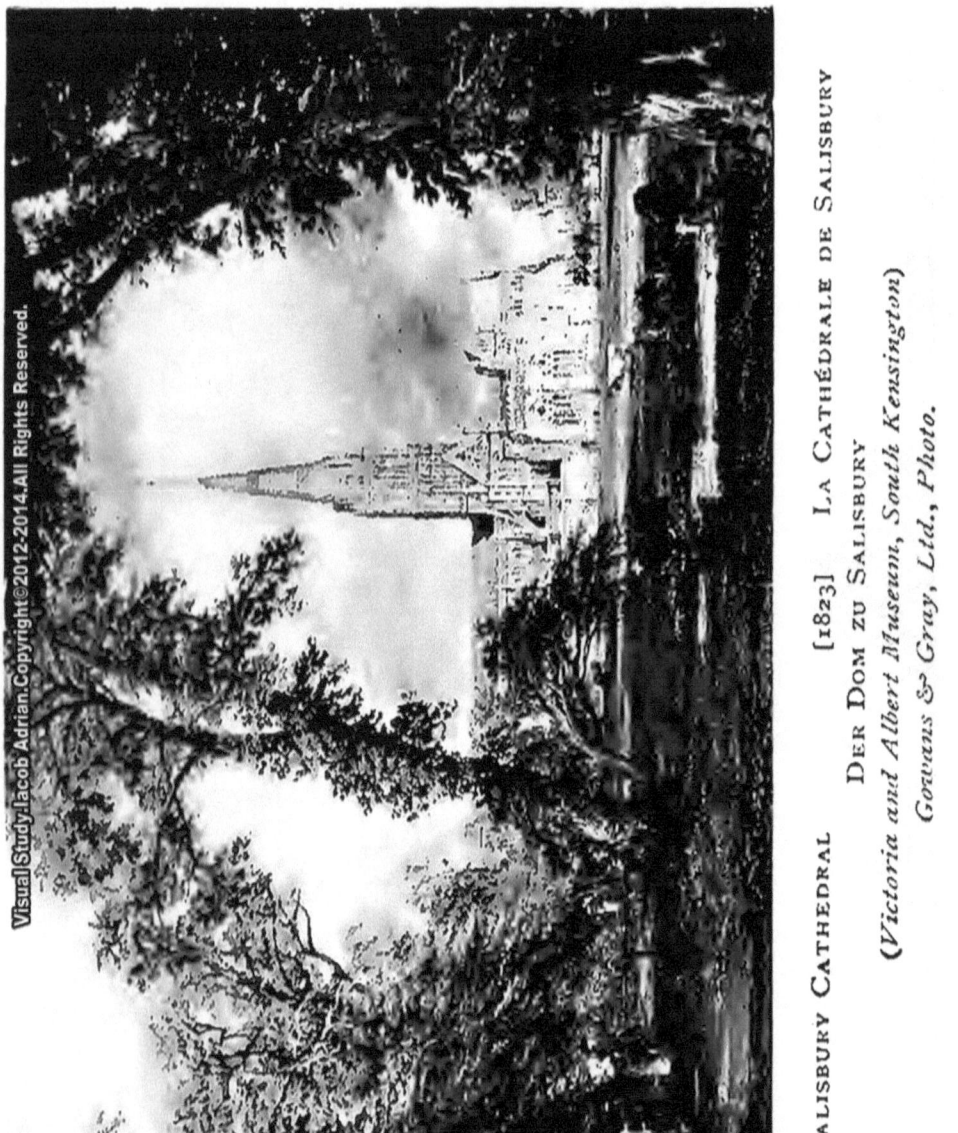

SALISBURY CATHEDRAL [1823] LA CATHÉDRALE DE SALISBURY
DER DOM ZU SALISBURY
(*Victoria and Albert Museum, South Kensington*)
Gowans & Gray, Ltd., Photo.

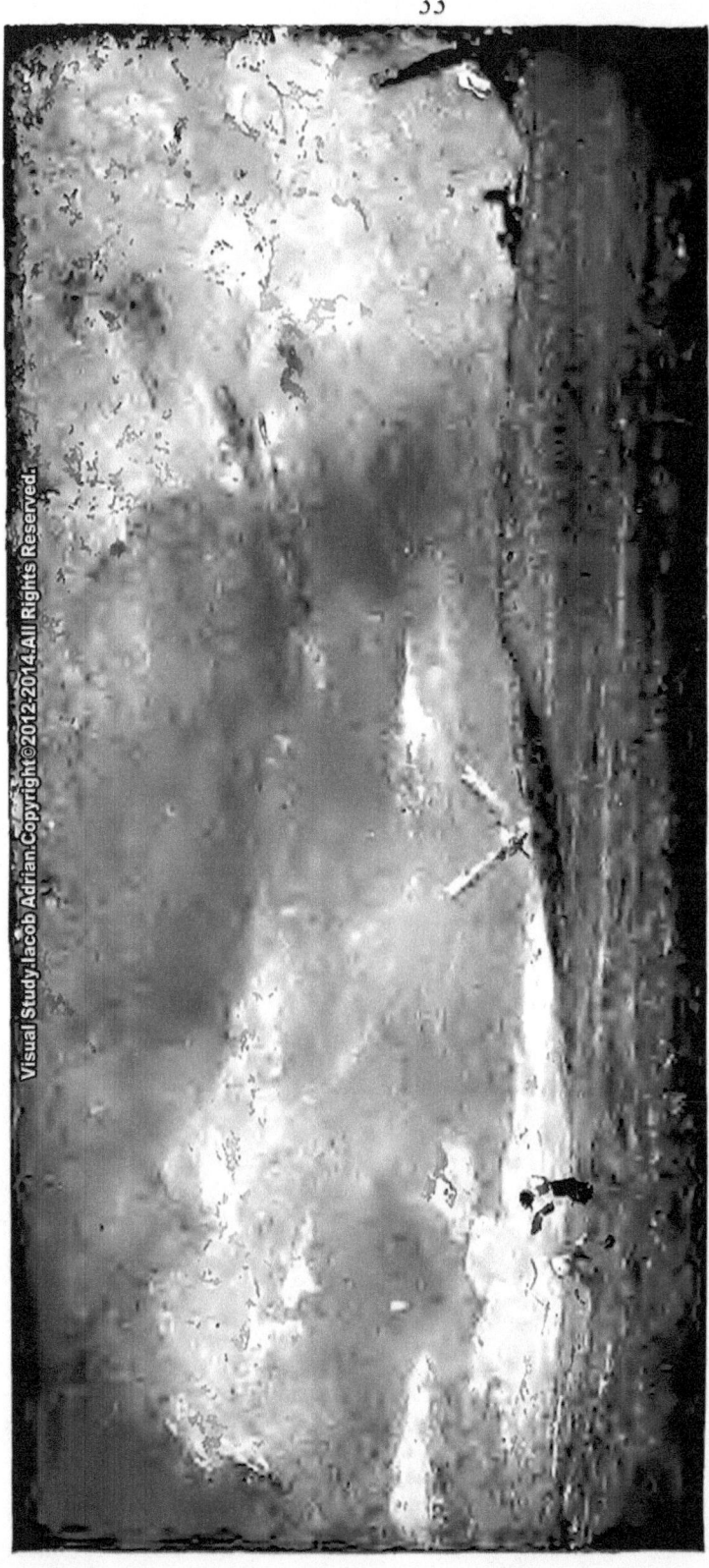

THE GLEANERS
(*National Gallery, London*)

[1824]
DIE NACHLESER
(*London, Nationalgalerie*)
Gowans & Gray, Ltd., Photo.

LES GLANEURS
(*Galerie nationale, Londres*)

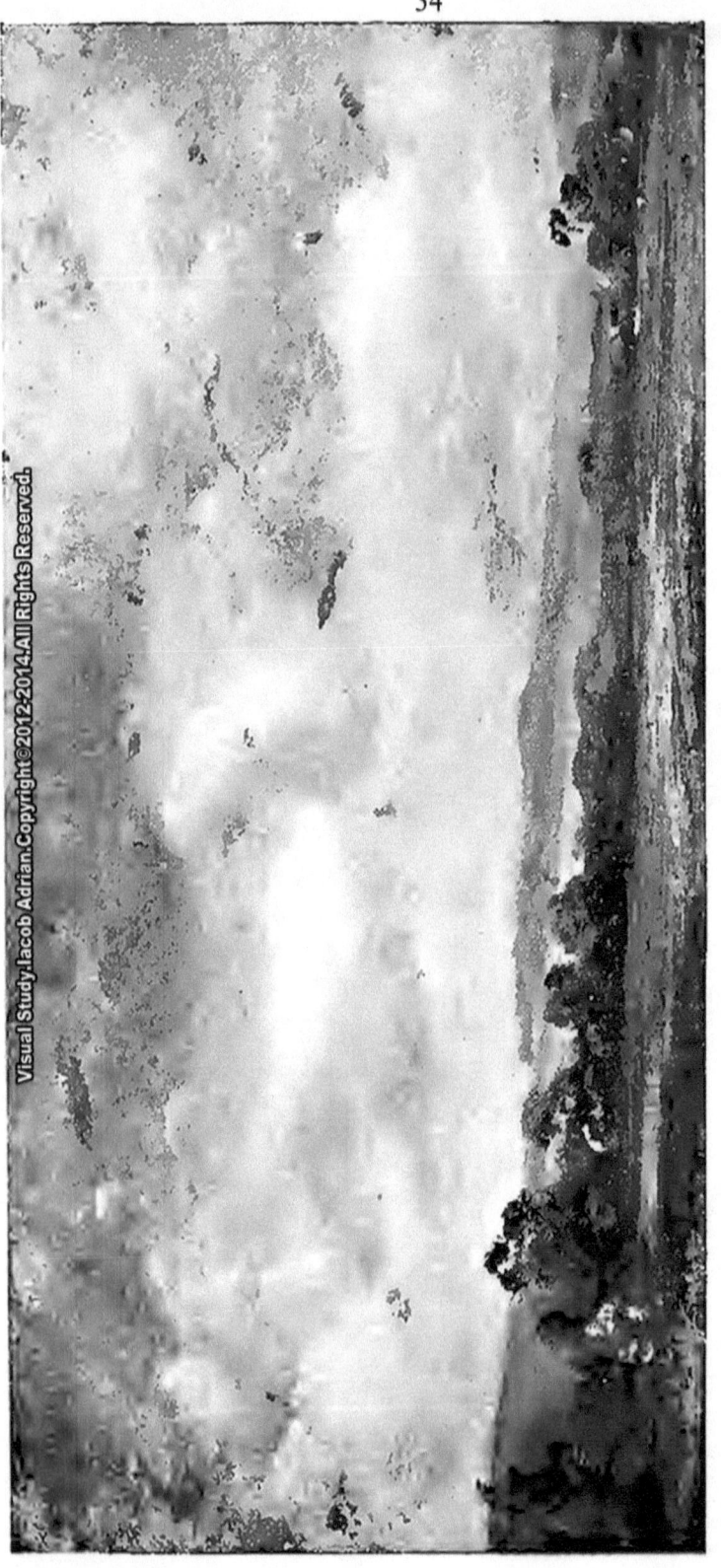

SKETCH OF A LANDSCAPE
(*National Gallery, London*)

[1824]
SKIZZE EINER LANDSCHAFT
(*London, Nationalgalerie*)
Gowans & Gray, Ltd., Photo.

ESQUISSE D'UN PAYSAGE
(*Galerie nationale, Londres*)

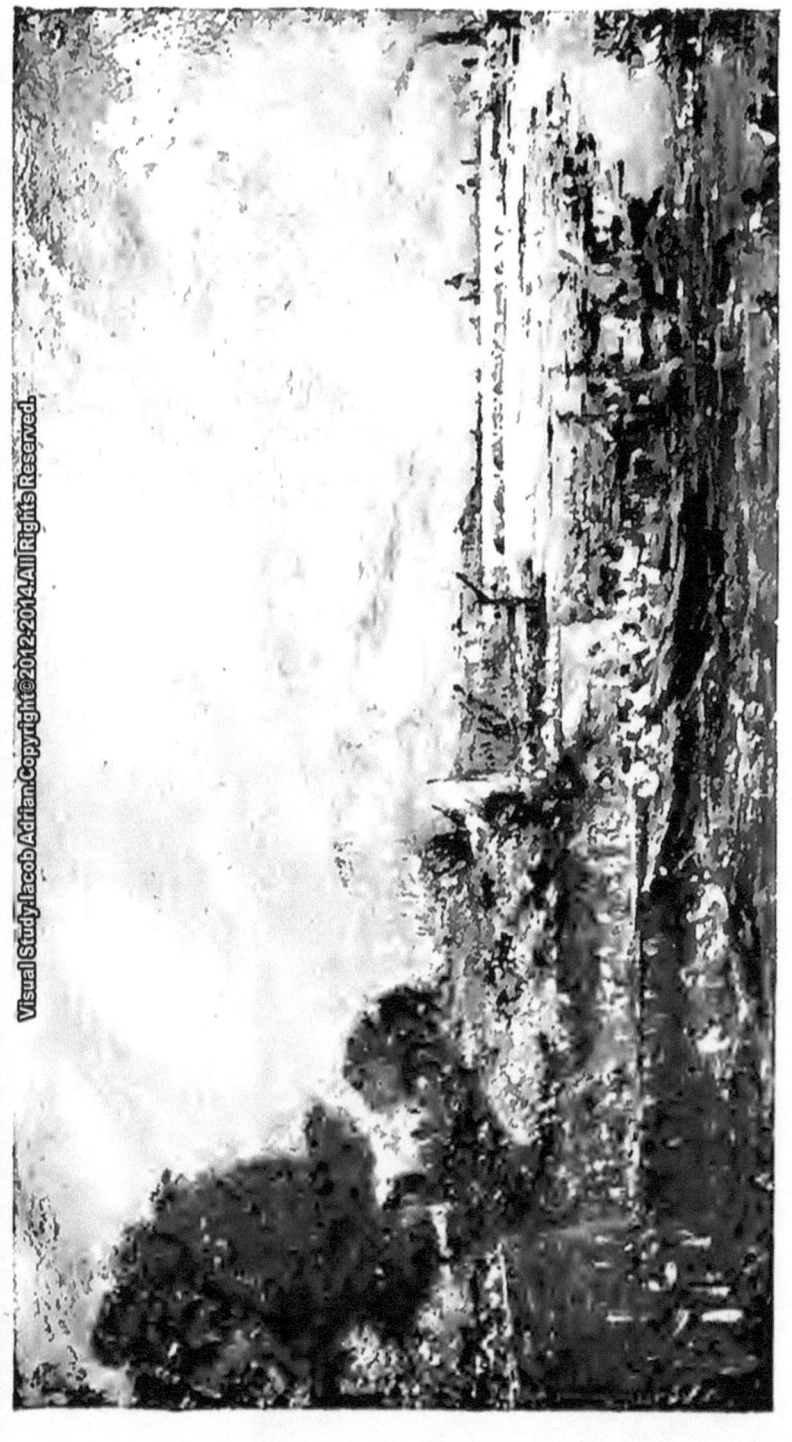

Study for the "Opening of Waterloo Bridge, 1817" [1824] Étude pour "L'Inauguration du Pont Waterloo, 1817"
Studie für die "Eröffnung der Waterloobrücke, 1817"
(Victoria and Albert Museum, South Kensington) Gowans & Gray, Ltd., Photo.

BRIGHTON BEACH DAS GESTADE VON BRIGHTON LA PLAGE DE BRIGHTON
[1824]
(*Victoria and Albert Museum, South Kensington*)
Gowans & Gray, Ltd., Photo.

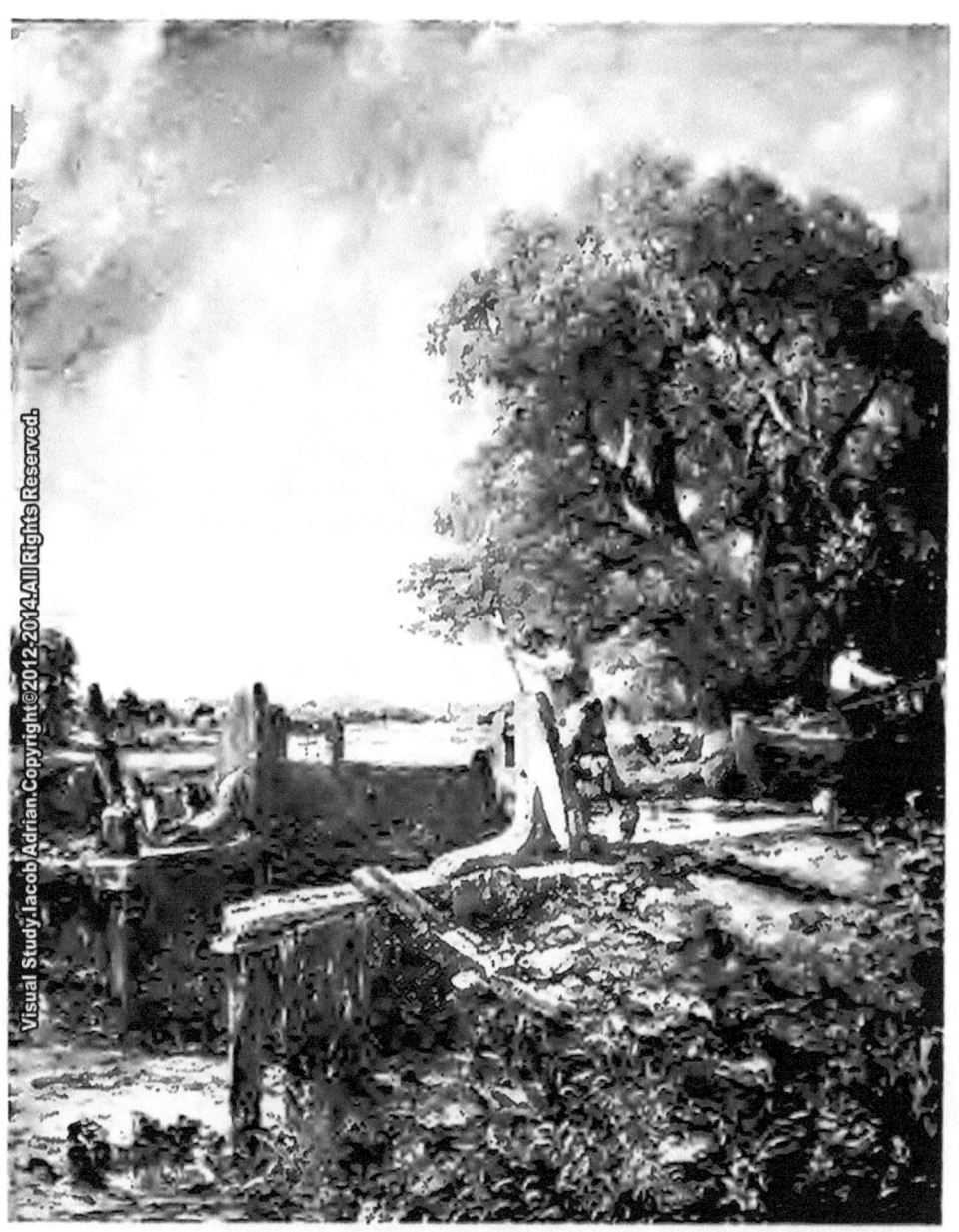

[1824]
THE LOCK DIE SCHLEUSE L'ÉCLUSE
(*The late Mr. Jas. Morrison, Basildon Park*)
W. A. Mansell & Co., Photo.

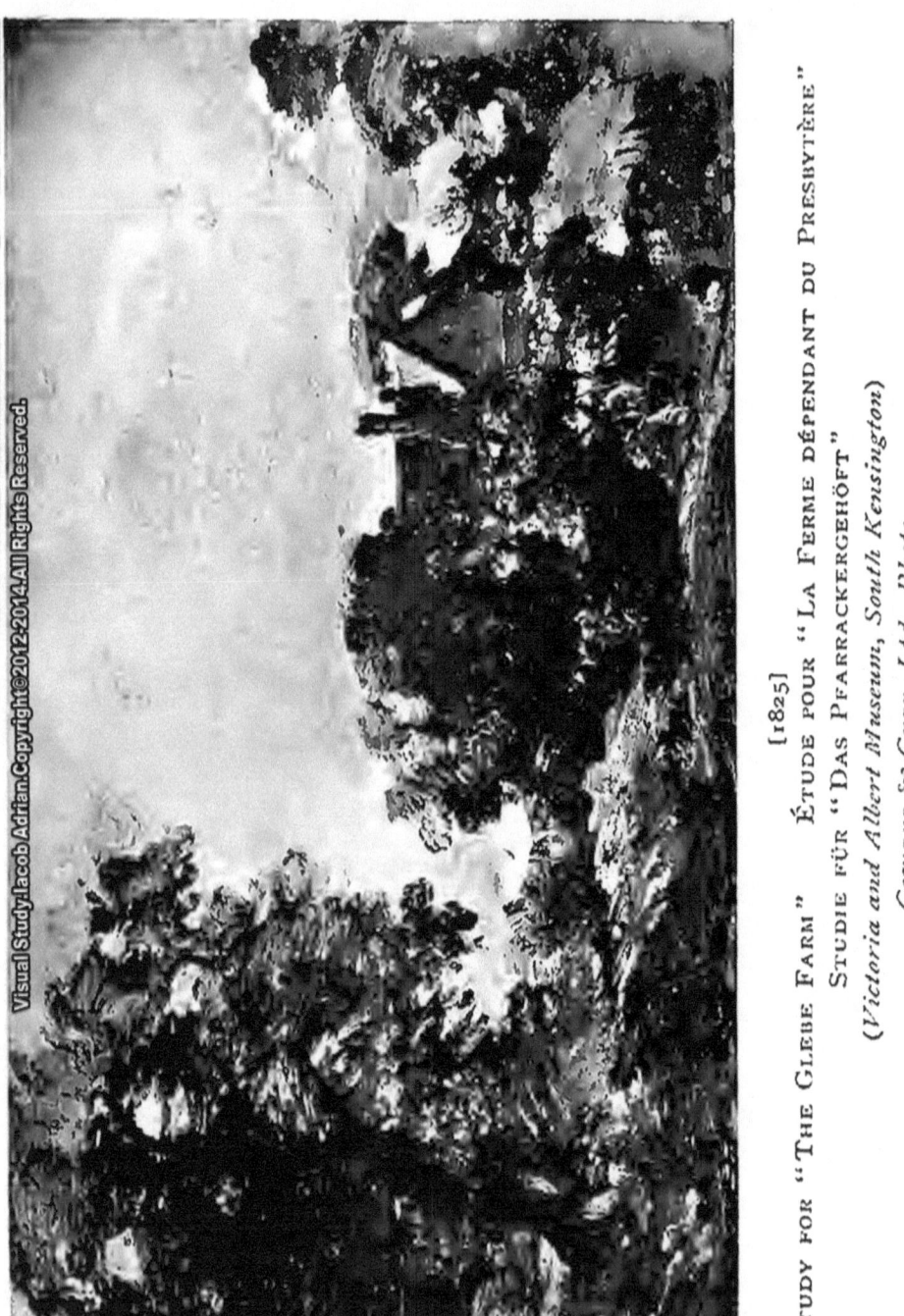

Study for "The Glebe Farm" Étude pour "La Ferme dépendant du Presbytère"
Studie für "Das Pfarrackergehöft"
(Victoria and Albert Museum, South Kensington)
Gowans & Gray, Ltd., Photo.

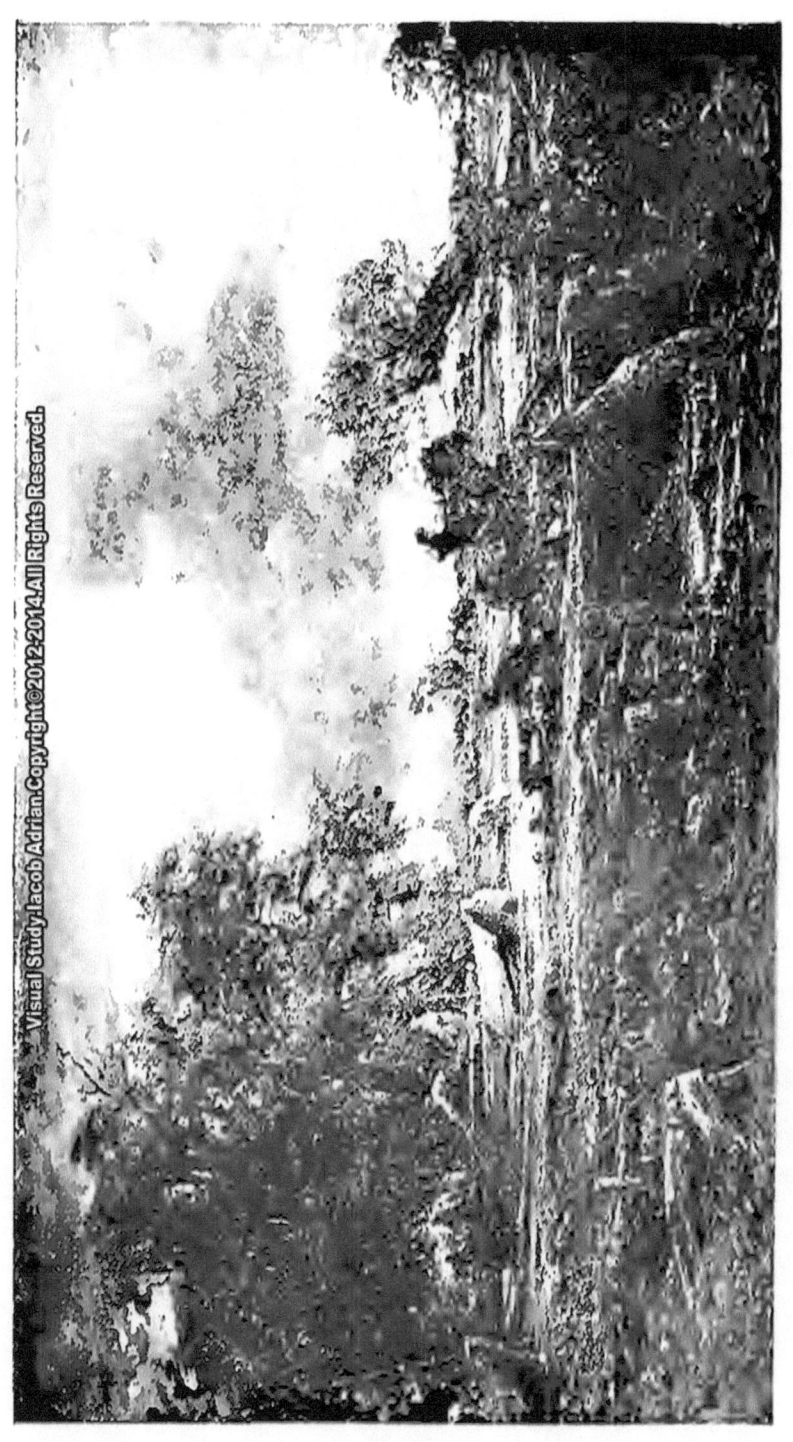

Study for "The Leaping Horse" [1825] Étude pour "Le Cheval sautant"
Studie für "Das springende Pferd"
(Victoria and Albert Museum, South Kensington)
Gowans & Gray, Ltd., Photo.

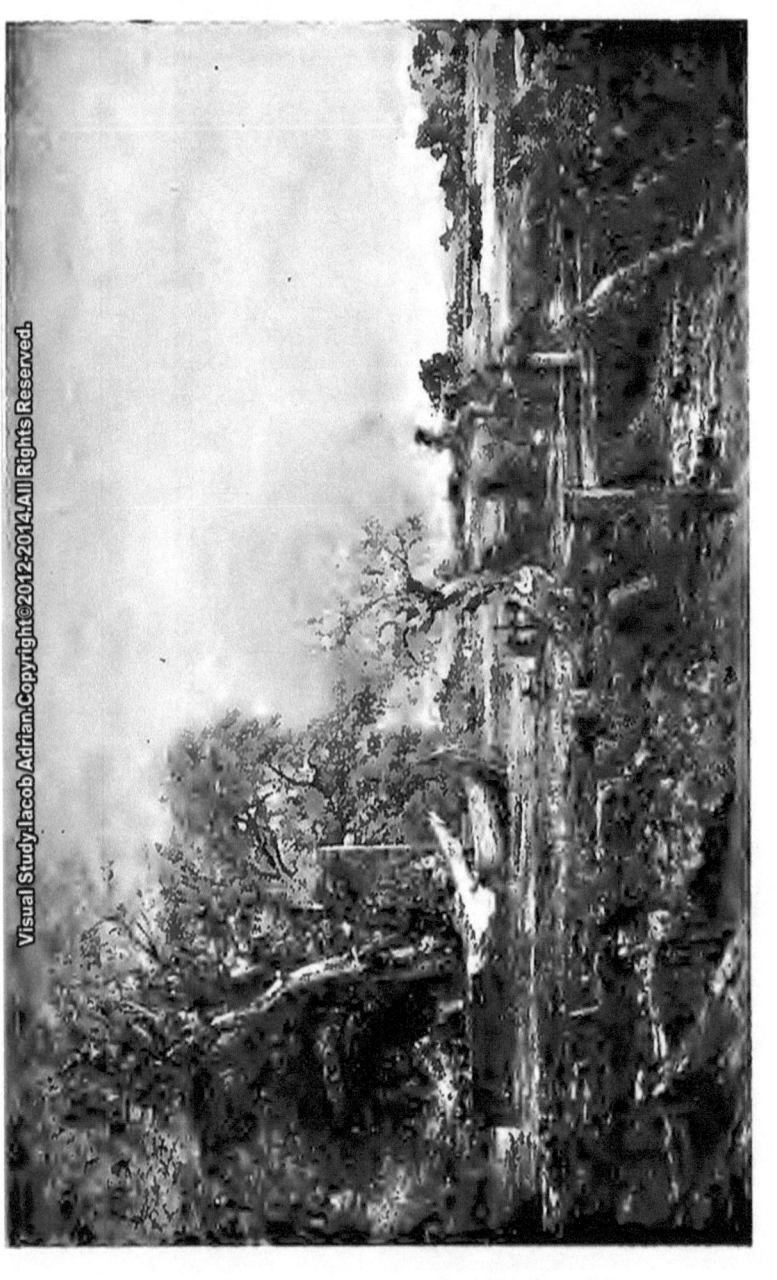

DEDHAM LOCK ("THE LEAPING HORSE") [1825] L'ÉCLUSE DE DEDHAM ("LE CHEVAL SAUTANT")
DIE SCHLEUSE VON DEDHAM ("DAS SPRINGENDE PFERD")
(*Royal Academy, London*) *Donald Macbeth, Photo.*
By permission of the President and Council

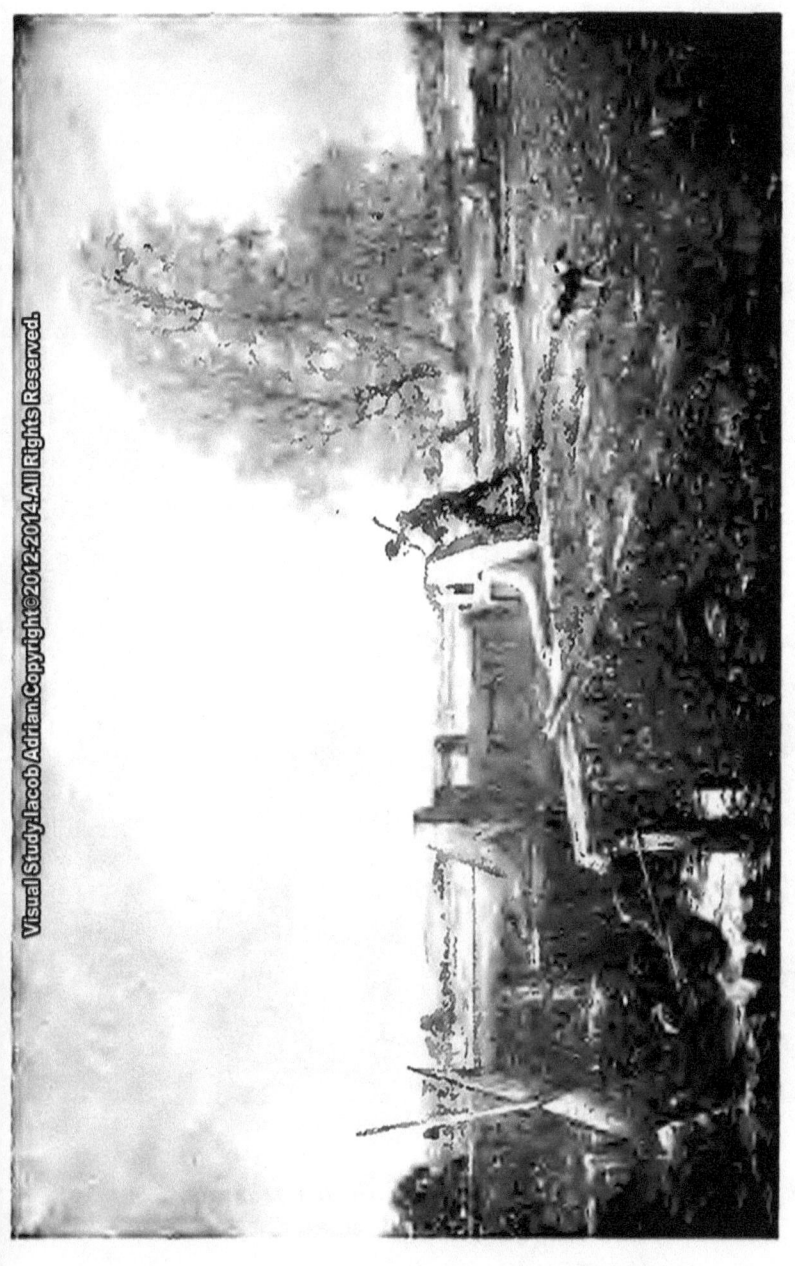

A LOCK [1825] UNE ÉCLUSE
EINE SCHLEUSE
(Royal Academy, London) Donald Macbeth, Photo.
By Permission of the President and Council

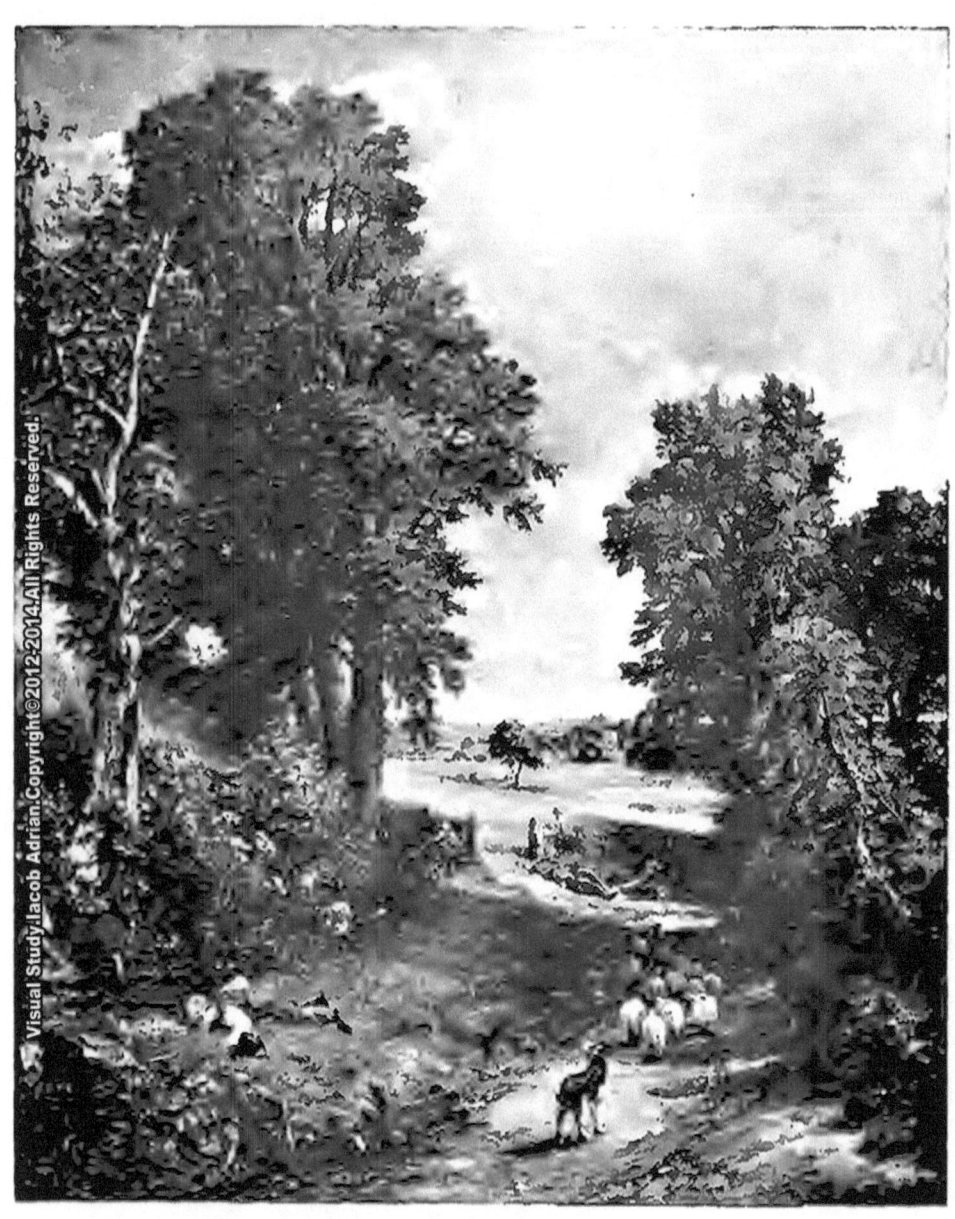

THE CORNFIELD [1826] LE CHAMP DE BLÉ
(*National Gallery, London*) (*Galerie nationale, Londres*)
DAS KORNFELD
(*London, Nationalgalerie*)
F. Hanfstaengl, Photo.

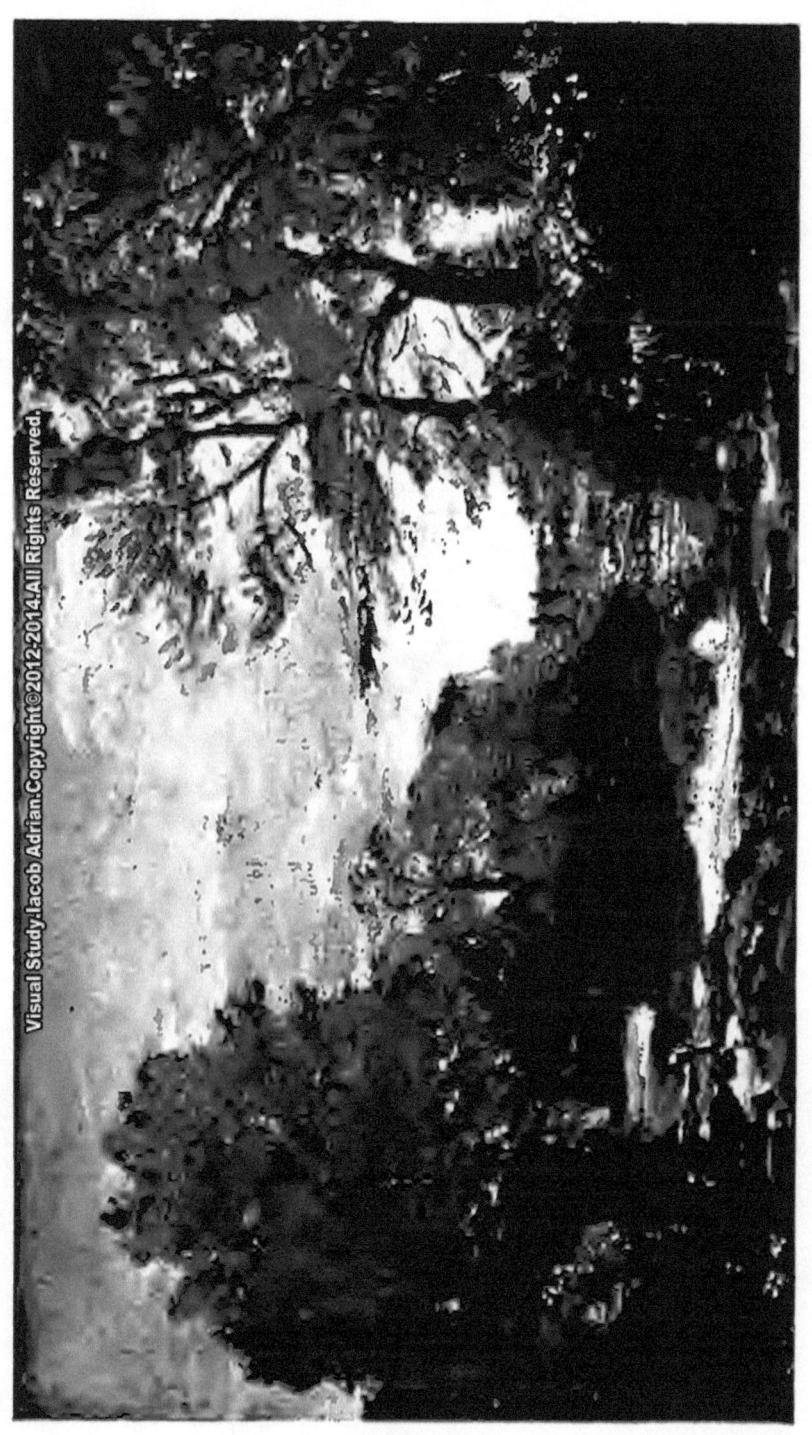

A Country Lane Eine ländliche Gasse Une Ruelle champêtre
(National Gallery, London) (London, Nationalgalerie) (Galerie nationale, Londres)

[1826]

Gowans & Gray, Ltd., Photo.

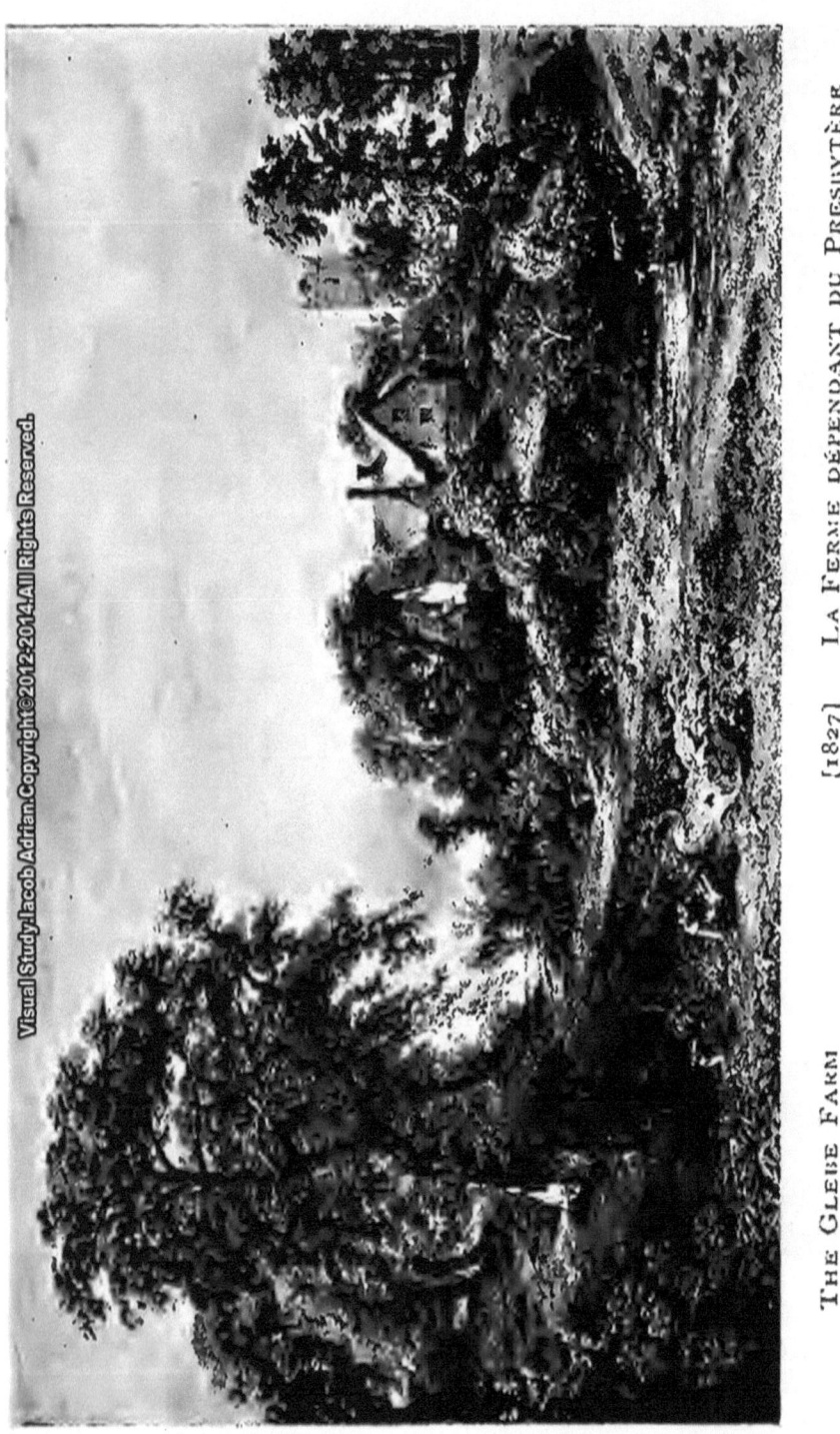

THE GLEBE FARM [1827] LA FERME DÉPENDANT DU PRESBYTÈRE
(*National Gallery, London*) (*Galerie nationale, Londres*)
DAS PFARRACKERGEHÖFT F. *Hanfstaengl, Photo.*
(*London, Nationalgalerie*)

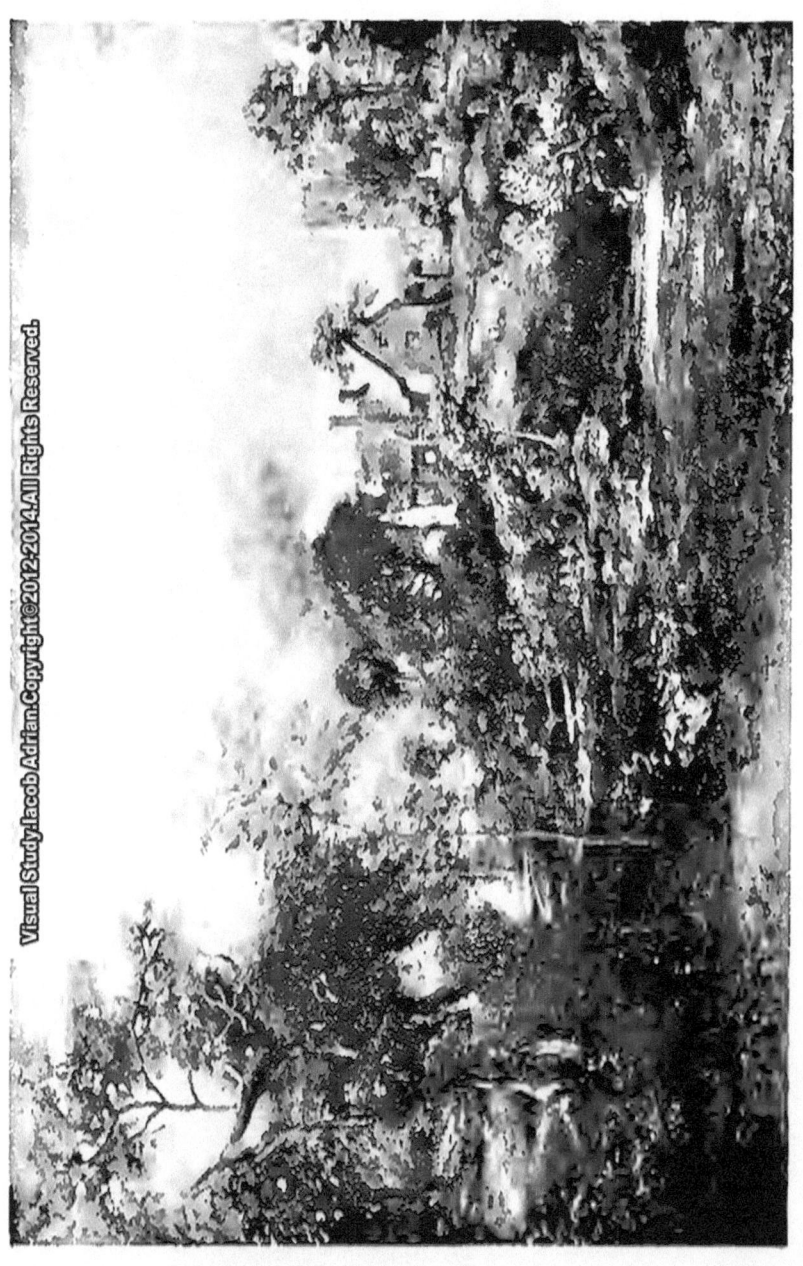

[1827] LA FERME DÉPENDANT DU PRESBYTÈRE
THE GLEBE FARM (*Galerie nationale, Londres*)
(*National Gallery, London*)
DAS PFARRACKERGEHÖFT

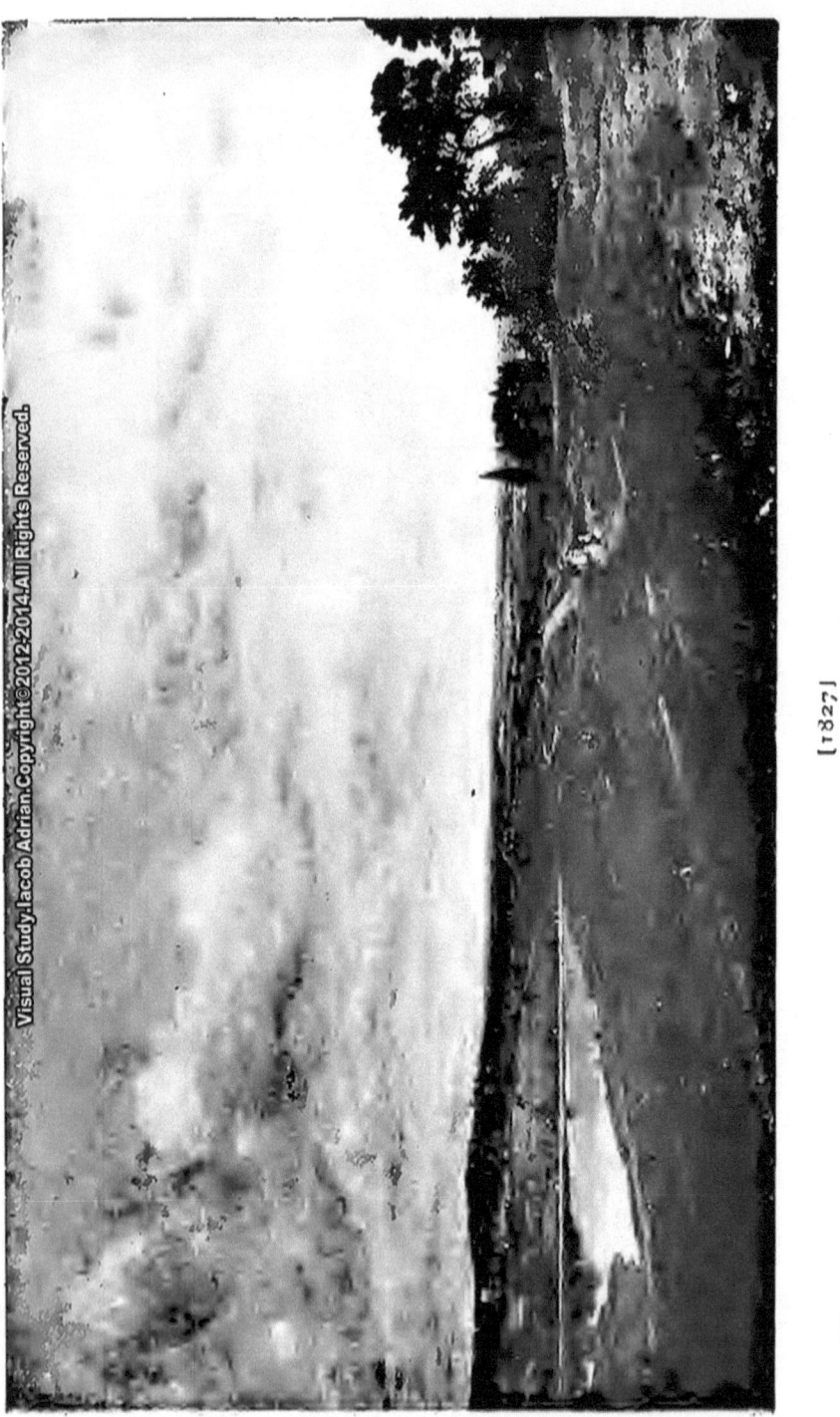

HAMPSTEAD HEATH HAMPSTEAD HEIDE LANDE DE HAMPSTEAD
[1827]
(Victoria and Albert Museum, South Kensington)
Gowans & Gray, Ltd., Photo.

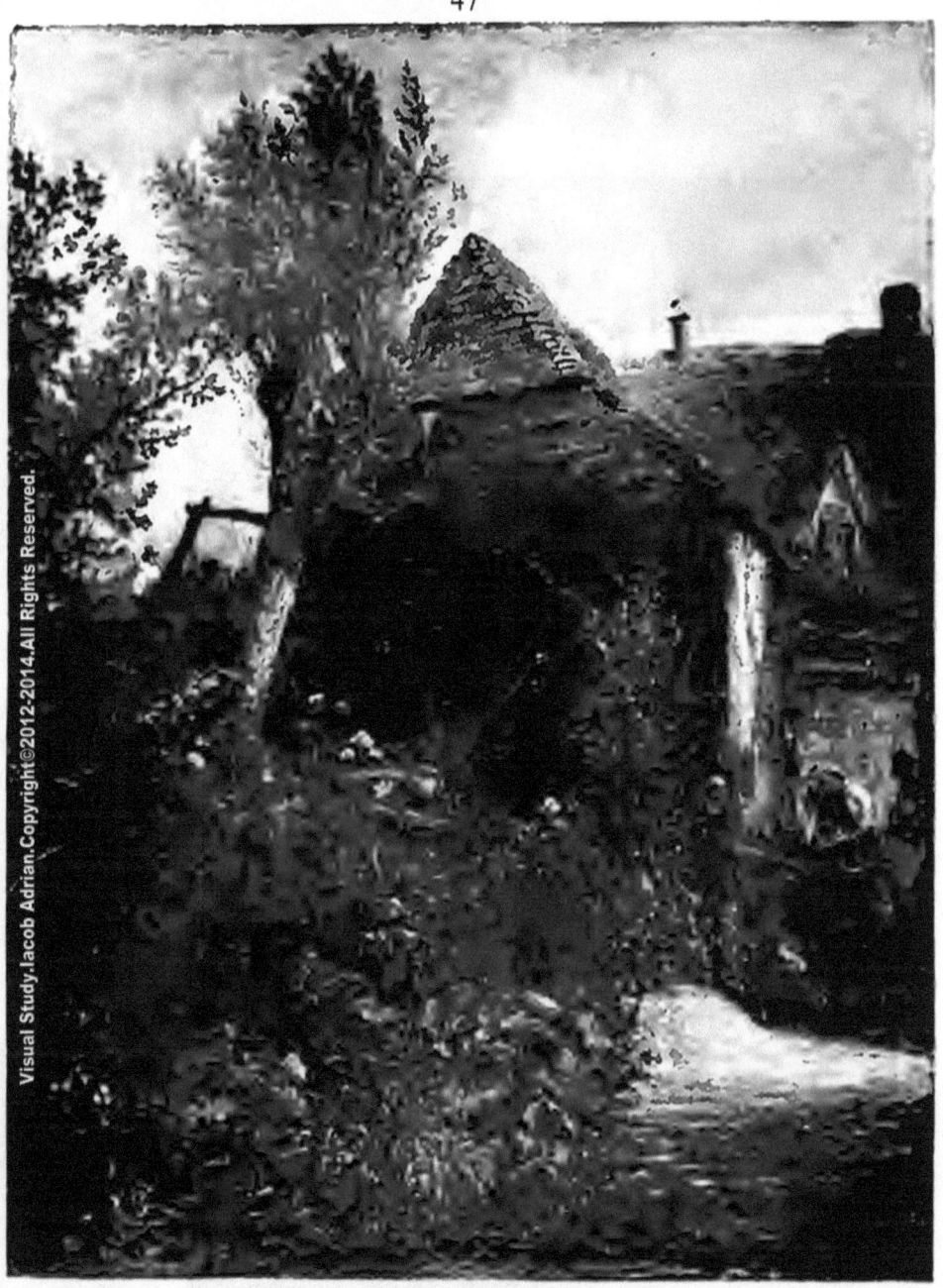

[1827]
WATERMILL AT GILLINGHAM MOULIN A EAU A GILLINGHAM
WASSERMÜHLE ZU GILLINGHAM
(*Victoria and Albert Museum, South Kensington*)
Gowans & Gray, Ltd., Photo.

[1823] Summer Afternoon after a Shower Après-Midi d'Été après une Averse
(National Gallery, London) (Galerie nationale, Londres)
Sommernachmittag nach einem Regenguss
(London, Nationalgalerie) Gowans & Gray, Ltd., Photo.

[1828]
DEDHAM
(National Gallery, London)
Gowans & Gray, Ltd., Photo.

[1829]

SALISBURY CATHEDRAL DER DOM ZU SALISBURY LA CATHÉDRALE DE SALISBURY
(National Gallery, London) (London, Nationalgalerie) (Galerie nationale, Londres)

Gowans & Gray, Ltd., Photo.

HAMPSTEAD HEATH HAMPSTEAD HEIDE LANDE DE HAMPSTEAD
[1830]
(*Victoria and Albert Museum, South Kensington*)
Gowans & Gray, Ltd., Photo.

[1831] La Cathédrale de Salisbury (Étude)
(Galerie nationale, Londres)
Salisbury Cathedral (Study)
(National Gallery, London)
Der Dom zu Salisbury (Studie)
(London, Nationalgalerie)

Cowans & Gray, Ltd., Photo.

[1831]
STOKE-BY-NAYLAND
(*National Gallery, London*)
Gowans & Gray, Ltd., Photo.

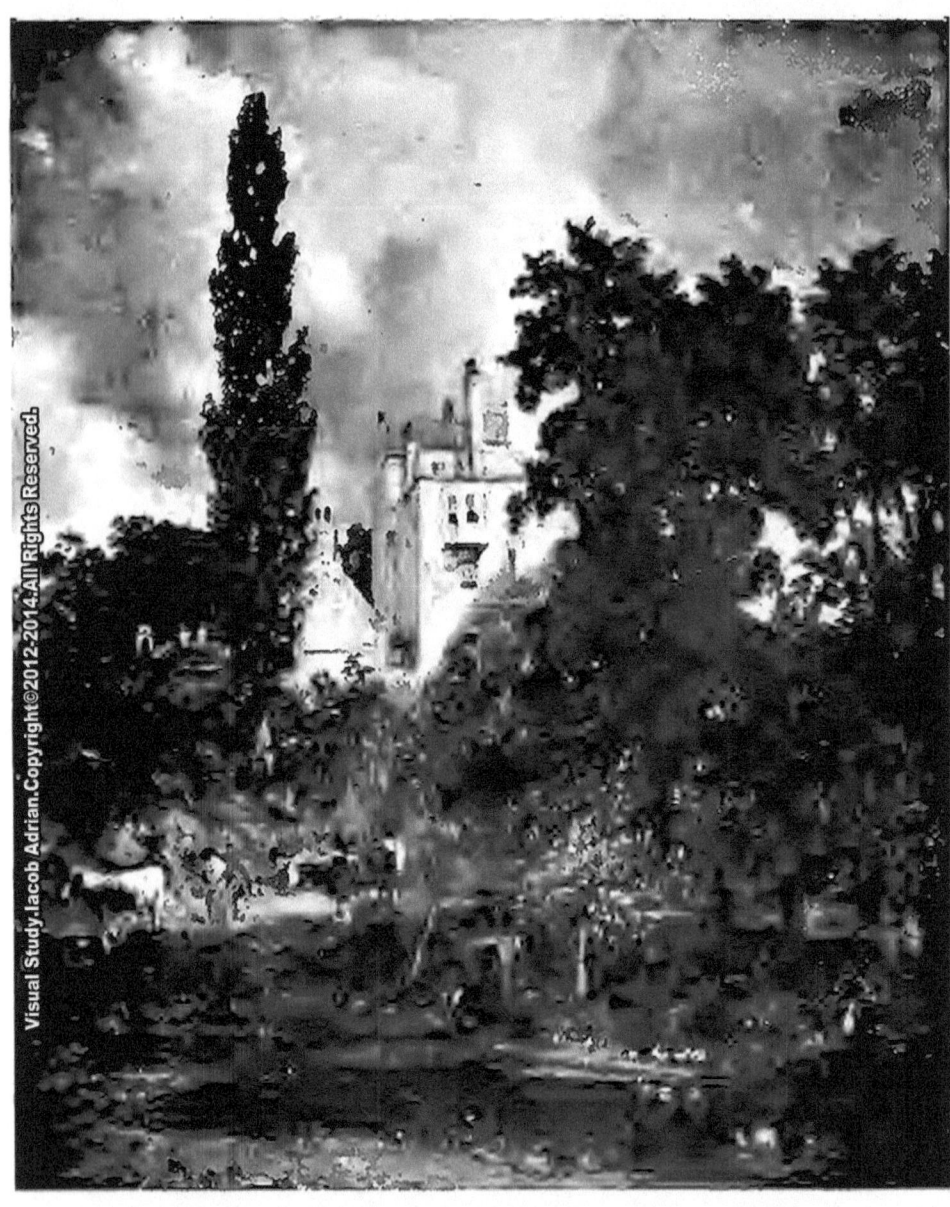

A ROMANTIC HOUSE, [1832?] UNE MAISON ROMANTIQUE,
HAMPSTEAD HAMPSTEAD
(National Gallery, London) (Galerie nationale, Londres)
EIN ROMANTISCHES HAUS, HAMPSTEAD
(London, Nationalgalerie)
Gowans & Gray, Ltd., Photo.

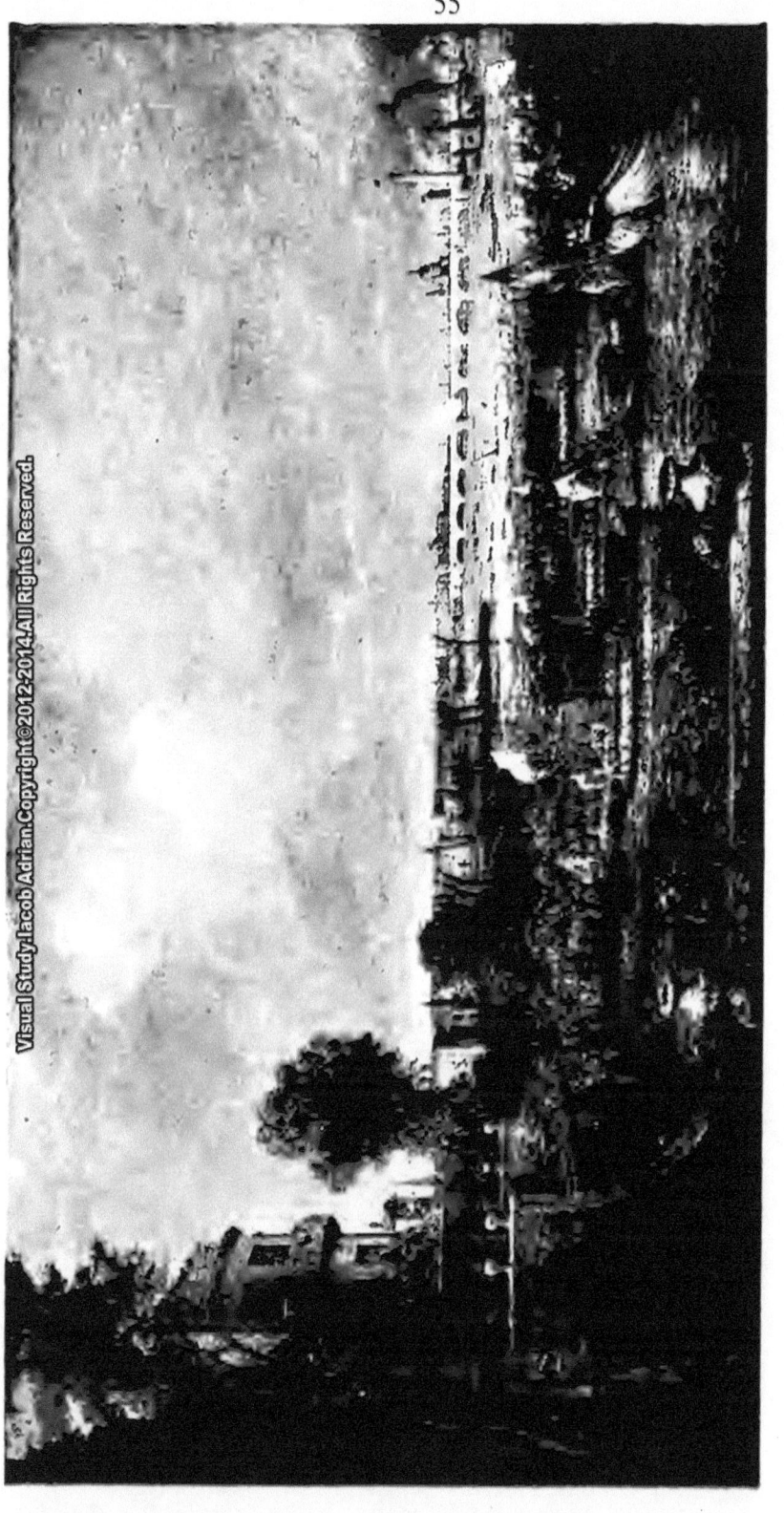

OPENING OF WATERLOO BRIDGE, 1817 [1832] INAUGURATION DU PONT WATERLOO, 1817
ERÖFFNUNG DER WATERLOOBRÜCKE. 1817
(Lord Glenconner, London) W. A. Mansell & Co., Photo.

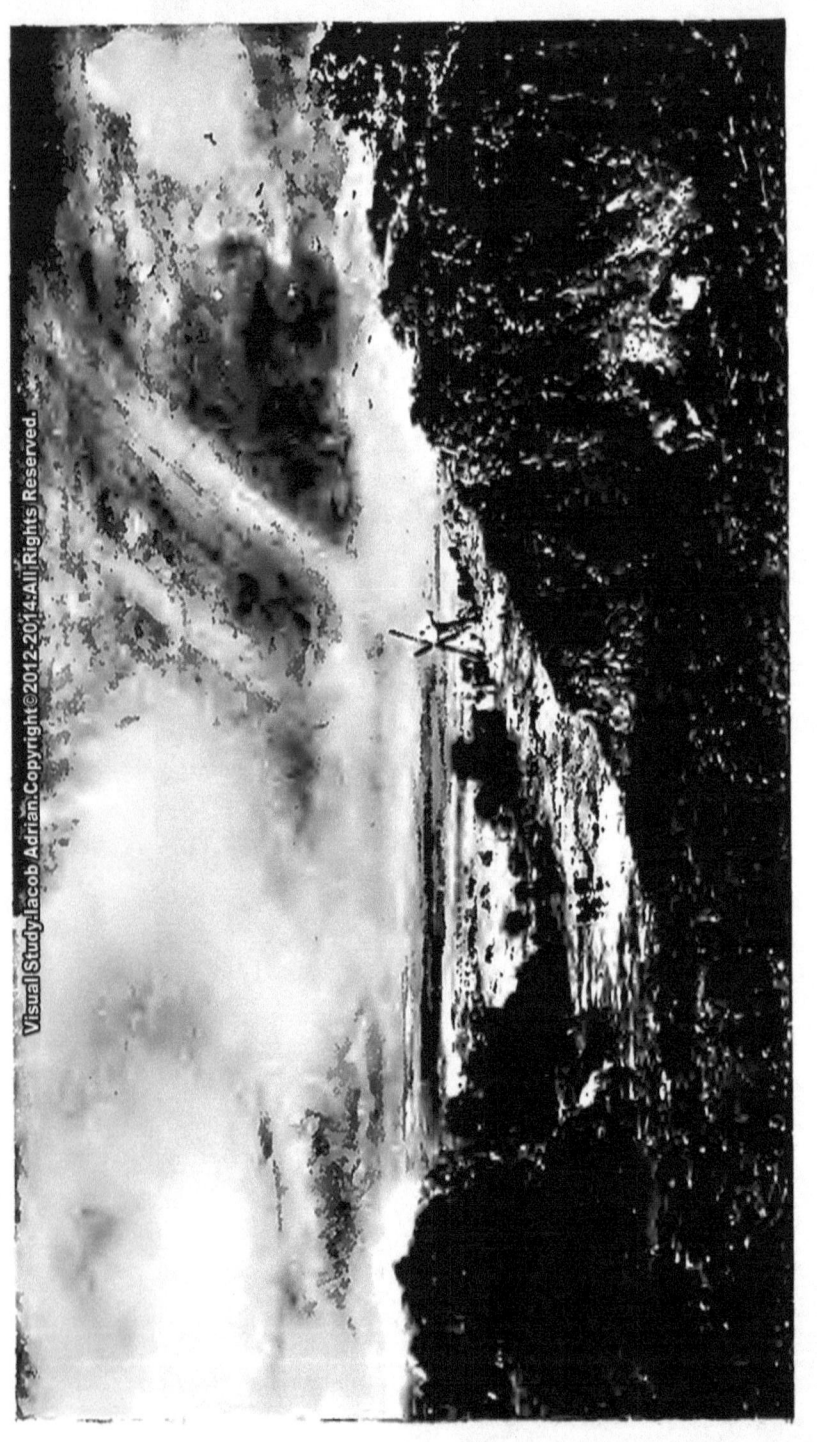

[1833]
HAMPSTEAD HEATH
(National Gallery, London)

HAMPSTEAD HEIDE
(London, Nationalgalerie)
Gowans & Gray, Ltd., Photo.

LANDE DE HAMPSTEAD
(Galerie nationale, Londres)

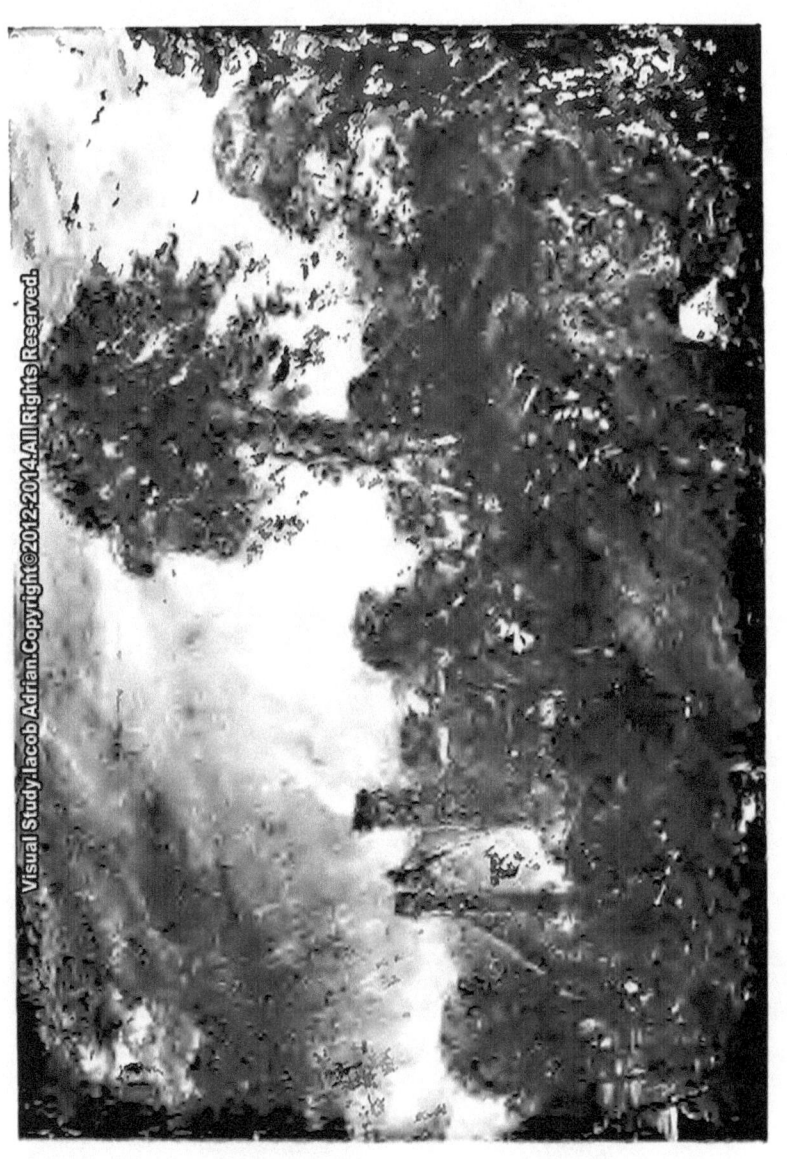

[1834]

COTTAGE AMONG TREES, WITH CHAUMIÈRE PARMI DES ARBRES, AVEC
SANDBANK BANC DE SABLE
HÜTTE UNTER BÄUMEN, MIT SANDBANK
(*Victoria and Albert Museum, South Kensington*) *Gowans & Gray, Ltd., Photo.*

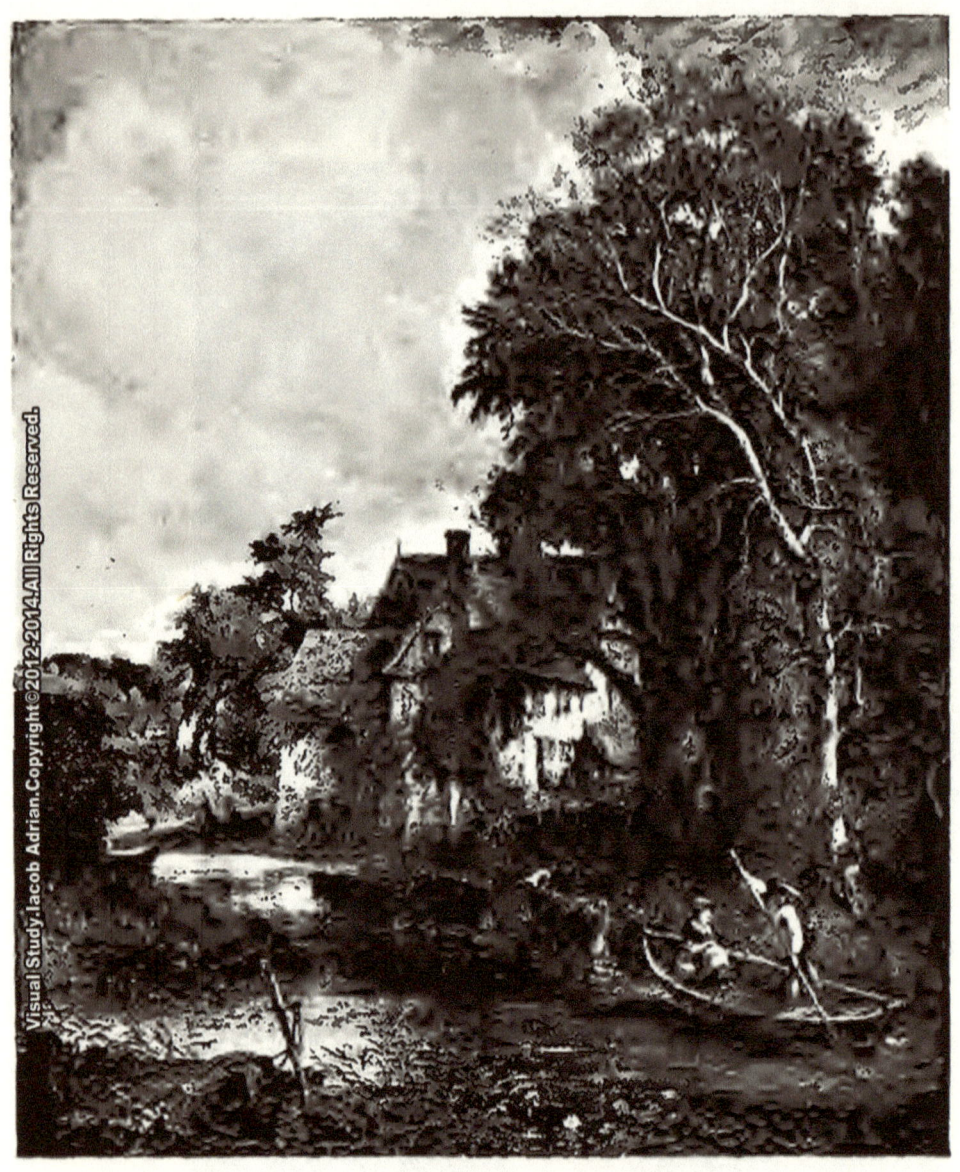

[1835]

THE VALLEY FARM LA FERME DANS LA VALLÉE
(*National Gallery, London*) (*Galerie nationale, Londres*)
DAS TALGEHÖFT
(*London, Nationalgalerie*)
F. Hanfstaengl, Photo.

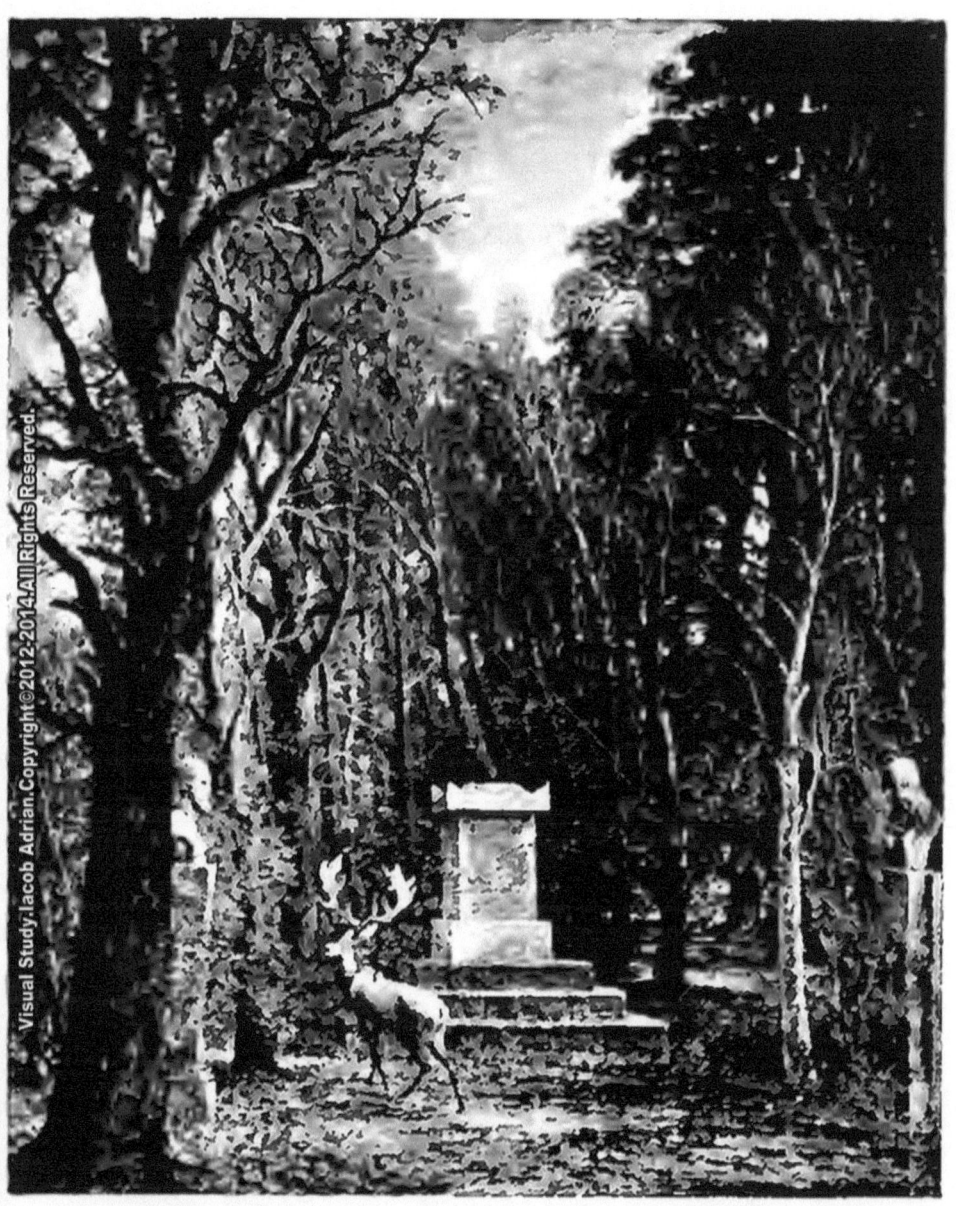

THE CENOTAPH [1836] LE CÉNOTAPHE
(National Gallery, London) (Galerie nationale, Londres)
DAS EHRENGRAEMAL
(London, Nationalgalerie)
F. Hanfstaengl, Photo.

Bibliographic sources :

The masterpieces of Constable (1776-1837). Sixty reproductions of photographs from the original paintings, affording examples of the different characteristics of the artist's work (1910)

Author: Constable, John, 1776-1837

Publisher: New York, F.A. Stokes Company

This documentary study use,
combined in various proportions,
elements from the following categories,
forms and subsets :
- fair use
- documentary
- documentary photography
- feature
- journalism
- arts journalism
- visual journalism
- photojournalism
- celebrity photography
in order to :
- employ material as the object of cultural critique ,
- quote to illustrate an argument or point ,
- use material in historical sequence,
providing independent opinion,
using photos, press articles, advertisements,
opinions of fans etc. ...

Copyright©2012-2014 Iacob Adrian
All Rights Reserved.

www.ingramcontent.com/pod-product-compliance
Lightning Source LLC
Chambersburg PA
CBHW021022180526
45163CB00005B/2065